Drawing Realistic Pets
FROM PHOTOGRAPHS

LEE HAMMOND

NORTH LIGHT BOOKS
CINCINNATI, OHIO
www.artistsnetwork.com

About the Author

Me and my dog Penny.

Polly "Lee" Hammond is an illustrator and art instructor from the Kansas City area. She owns and operates a private art studio called Take It To Art,* where she teaches realistic drawing and painting. Lee is also a certified police artist for the Kansas City metro area and is one of the forensic illustrators on call for the TV show *America's Most Wanted*. She is currently writing a book about her experiences working with law enforcement.

Lee was raised and educated in Lincoln, Nebraska, and she established her career in illustration and teaching in Kansas City, Kansas. Although she has lived all over the country, she will always consider Kansas City home. Lee has been an author with North Light Books since 1994. She also writes and illustrates articles for other publications such as *The Artist's Magazine*.

Lee is continuing to develop new art instruction books for North Light and has also begun illustrating children's books. Fine art and limited-edition prints of her work will also be offered soon. Lee lives in Overland Park, Kansas, along with her family. You may contact Lee via e-mail at Pollylee@aol.com or visit her Web site at www.LeeHammond.com.

Take It To Art is a registered trademark for Lee Hammond.

Other fine North Light Books are available from your local bookstore, art supply store or direct from the publisher.

10 09 6 5

Library of Congress Cataloging in Publication Data
Hammond, Lee
 Drawing realistic pets from photographs / Lee Hammond.–1st ed.
 p. cm.
 Includes index.
 ISBN-13: 978-1-58180-640-3 (pbk. : alk. paper)
 ISBN-10: 1-58180-640-X (pbk. : alk. paper)
 1. Animals in art. 2. Pencil drawing–Technique. 3. Drawing from photographs. I. Title.
 NC783.8.P48H36 2005
 743.6–dc22 2005000266

Editors: Gina Rath and Stefanie Laufersweiler
Production editor: Kelly Messerly
Cover design by: Davis Stanard, Stanard Design
Interior design by: Wendy Dunning
Production artist: Joni DeLuca
Production coordinator: Mark Griffin

DISTRIBUTED IN CANADA BY FRASER DIRECT
100 Armstrong Avenue
Georgetown, ON, Canada L7G 5S4
Tel: (905) 877-4411

DISTRIBUTED IN THE U.K. AND EUROPE BY
DAVID & CHARLES
Brunel House, Newton Abbot, Devon,
TQ12 4PU, England
Tel: (+44) 1626 323200, Fax: (+44) 1626 323319
Email: mail@davidandcharles.co.uk

DISTRIBUTED IN AUSTRALIA BY
CAPRICORN LINK
P.O. Box 704, S. Windsor NSW, 2756 Australia
Tel: (02) 4577-3555

METRIC CONVERSION CHART

To convert	to	multiply by
Inches	Centimeters	2.54
Centimeters	Inches	0.4
Feet	Centimeters	30.5
Centimeters	Feet	0.03
Yards	Meters	0.9
Meters	Yards	1.1
Sq. Inches	Sq. Centimeters	6.45
Sq. Centimeters	Sq. Inches	0.16
Sq. Feet	Sq. Meters	0.09
Sq. Meters	Sq. Feet	10.8
Sq. Yards	Sq. Meters	0.8
Sq. Meters	Sq. Yards	1.2
Pounds	Kilograms	0.45
Kilograms	Pounds	2.2
Ounces	Grams	28.3
Grams	Ounces	0.035

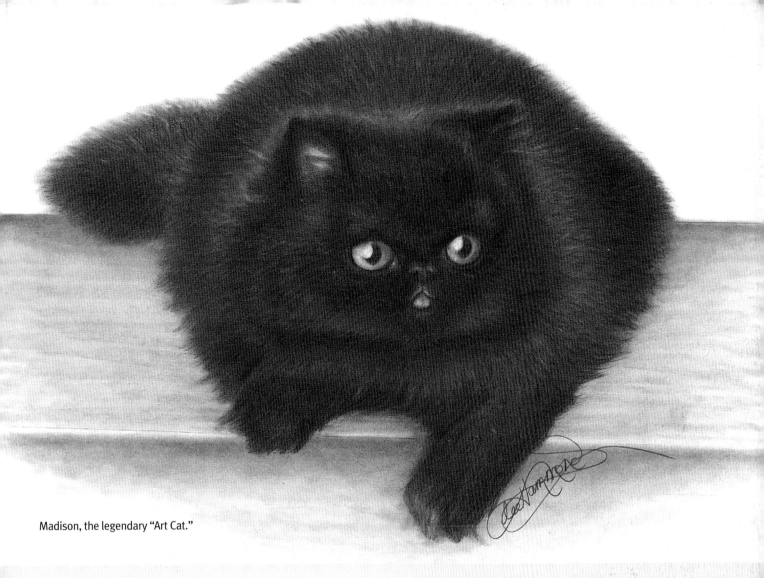

Madison, the legendary "Art Cat."

Dedication

This book is dedicated to all of the animals that desperately need our help and to the wonderful people at the thousands of shelters who dedicate their lives to saving those animals.

The drawing on this page is a tribute to Madison, a wonderful Persian cat who became a legend in my art studio. I found him at a local shelter, where he was close to death after being tortured: He had been bound with duct tape and thrown in a box over the shelter's fence. My incredible veterinarian, Dr. Douglas McAllister, helped me save Madison's life by coming to my studio every day to check on him and give him his medication. Without Dr. McAllister's generous house calls and loving care, Madison certainly would have died.

Madison lived in my studio for eight years, entertaining my art students until he died of old age during the writing of this book. He is missed terribly and will always be remembered by the hundreds of students whom he claimed as his family.

Acknowledgments

This book is a testimonial to how much animals and pets enhance our lives. I am in deep gratitude to the people of North Light Books for allowing me to write it. They are a wonderful group who constantly support me and my creative endeavors. Mona Michael and Jamie Markle are the best editors in the world, in my opinion. They help make my books the best that they can be. I also want to thank Stefanie Laufersweiler for joining this project to add her awesome expertise.

Special thank-yous are also in order for Pam Wissman and David Lewis for always giving me the opportunity to continue doing what I love with such a wonderful company.

Table of Contents

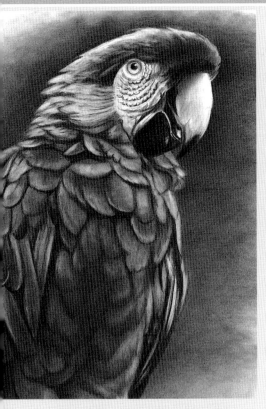
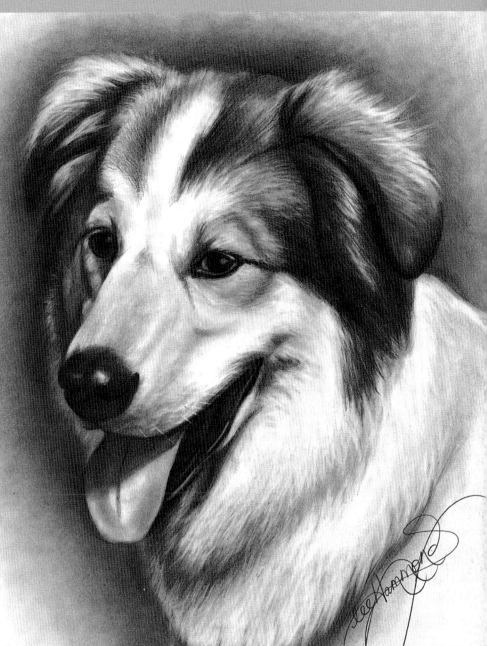
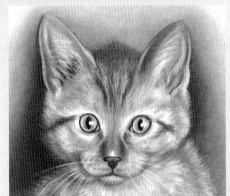
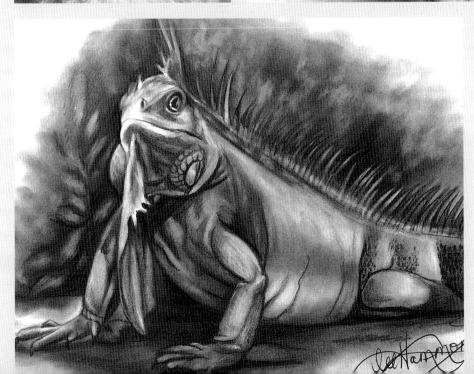

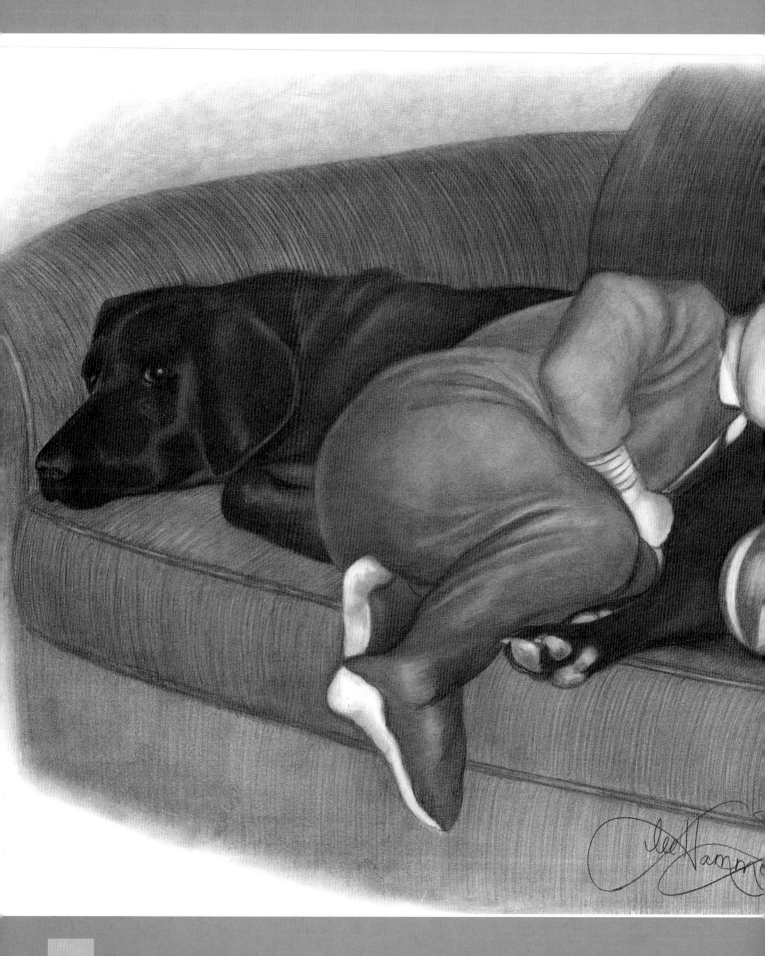

Introduction

Animals are a huge part of my life and always have been. I was lucky to have grown up with parents who also liked animals and indulged me with every type of pet imaginable. I remember my bedroom being my own personal zoo, a place I could escape to and surround myself with my furry and feathered friends while I drew pictures and read books.

I cannot recall many nights in my life when I didn't share my bed with a cat or dog or share my dinner with a guinea pig or other rodent. To this day, I can't sleep without the sound of an aquarium bubbling in the night. Even now, as I sit at my computer, my cat Burnie is curled up on my lap, and my dogs, Penny and Misty, are at my feet.

For me, life would be so empty without pets. I find that most of my art students feel the same way. They enjoy coming to my studio where my dogs and cats roam freely, taking cuddles and behind-the-ear scratches from anyone who will offer. Maybe creativity goes hand in hand with love and compassion, and artists crave the cozy feeling that pets bring to us.

Artwork is always more inspirational when you are in love with your subject matter. If you have purchased this book, it is likely because you love pets, too. This book isn't just about drawing animals. It is about animal "portraiture"—capturing the soul and essence of the pet that is a member of your family, and preserving their memory forever through art. Through your drawings, you can capture the actions and behaviors, the love and devotion, the fun-loving personality and gentle spirit of your wonderful pets.

My camera is always at my fingertips to capture my pets' antics. They provide me with endless opportunity for fun-filled artwork. In this book, I will guide you step by step through the techniques required for creating a quality portrait from a photograph. I will show you how to capture the soul in pets' eyes and the softness of their fur. Or, if your favorite pet is not furry at all, I can show you how to render textures such as scales or shells.

No matter how little drawing experience you have, you too can create a work of art, suitable for framing, that will capture your beloved pet forever.

A Well-Deserved Rest
This is what happens when two babies play too hard. This drawing shows my grandson and "grandpuppy" after a hard morning of playing ball. This type of photograph can make for a priceless drawing. Always have your camera ready for sweet shots such as this.

GAVYN AND SHASTA, MORNING NAP
11" × 14" (28CM × 36CM)

1 You Can Do It!

I believe that I can teach anyone to draw. Drawing is simply a matter of following directions and paying attention to detail. I am never surprised, but always filled with joy, when I see students succeed, especially when they thought their artistic pursuit was hopeless.

By following the examples and projects in this book, you will be able to effectively teach yourself to draw. Practice is very important and necessary, so draw as much as you can, even though you may not feel that your drawings are as good as you'd hoped. It takes time and diligence. I taught myself through years and years of trial and error. With this book as your guide, hopefully you will grow artistically much more quickly than I did!

On the following pages are a couple of examples that show the successful results you can achieve in only a short period of time. Have fun!

Before
This drawing is a perfect example of student doubt. This is Nora's first attempt at drawing a cat. The application of pencil lines is rough and sketchy looking, indicative of a beginner. The artist was very unsure of herself and how to make her drawing look realistic and finished. Nora had not taken any drawing classes and was sure she couldn't create a piece of art she would want to frame. When she took my class, I was more than pleased to prove her wrong.

FIRST ATTEMPT AT DRAWING SCOOP
ARTIST: NORA MARTYNIAK

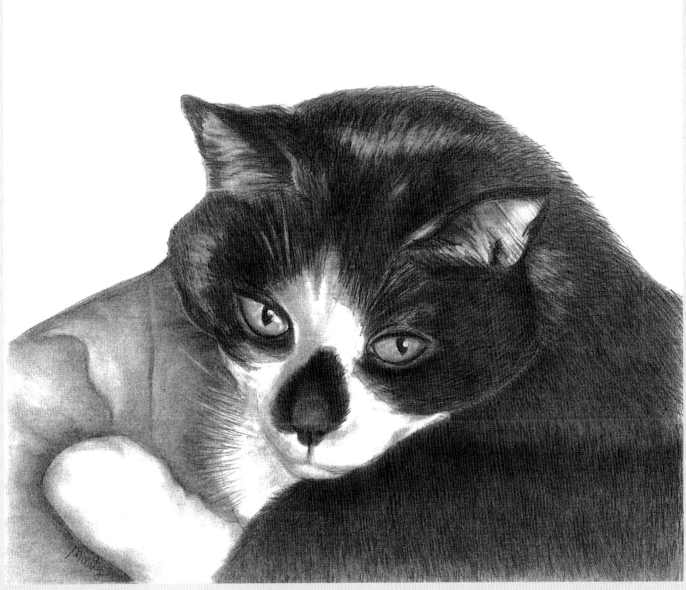

After

As you can see, Nora's second attempt is wonderful. By following the methods and techniques that I use, she went home with a beautiful drawing that she is very proud of. I showed her how to use her pencil to create realism in her textures and forms. Completed just days after her first attempt, the result is a polished look and an accurate portrayal of what her cat really looks like.

SECOND ATTEMPT
PORTRAIT OF SCOOP
ARTIST: NORA MARTYNIAK

Before

This sketch is very well executed. The shape is accurate, and the proportions are well described. However, the lack of tone keeps this drawing from looking finished.

FIRST ATTEMPT AT DRAWING A POMERANIAN
ARTIST: KRISTYN GEORGES, AGE 16

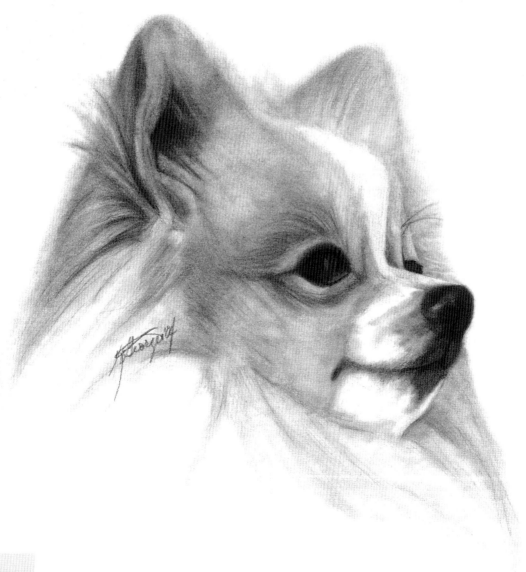

After

This drawing looks complete and professional. The addition of tone, blending and texture gives it a very realistic appearance.

SECOND ATTEMPT
ARTIST: KRISTYN GEORGES

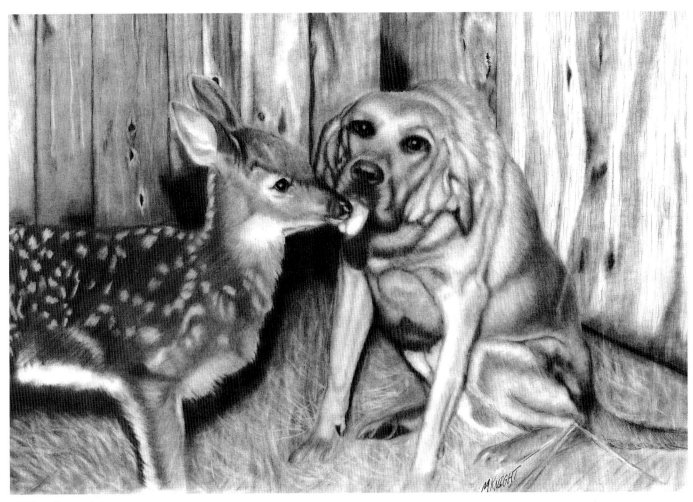

Aiming Beyond Accuracy

Combine good, accurate drawing techniques with attention to detail and you can tell a wonderful story through your artwork. This drawing, done by one of my students, shows the gentle nature of a Labrador retriever. The fawn looks totally at ease with the dog. I love the way the artist included the surroundings of the scene, creating the feel of a barn with the wood wall behind the animals. These types of details are very important in visual storytelling, which you'll learn more about in chapter ten.

BEST FRIENDS
ARTIST: MARK KNIGHT
14" X 17" (36CM X 43CM)

2 Materials & Techniques

You cannot do quality artwork with inadequate art materials. My blended-pencil technique requires the right tools to create the look. Don't scrimp in this department or your artwork will suffer. I have seen many of my students blame themselves for being untalented when their supplies were keeping them from doing a good job. The following tools will help you be a better artist.

A Mechanical Pencil and Blending Tortillions
Mechanical pencils are great for fine lines and details, and you never have to sharpen them. Tortillions are the secret to my whole technique, so be sure to buy a large and a small tortillion.

Smooth Bristol Boards or Sheets—Two-Ply or Heavier
This paper is very smooth (plate finish) and can withstand the rubbing associated with a technique I'll show you later in the book.

5mm Mechanical Pencil With 2B Lead
The brand of pencil you buy is not important; however, they all come with HB lead—you'll need to replace that with 2B lead. These pencils are good for fine lines and details.

Blending Tortillions
These are spiral-wound cones of paper. They are not the same as the harder, pencil-shaped stumps, which are pointed at both ends. Tortillions are better suited for the blended-pencil technique. Buy both a large and a small.

Kneaded Eraser
These erasers resemble modeling clay and are essential to a blended-pencil drawing. They gently "lift out" highlights without ruining the surface of the paper.

Typewriter Eraser With a Brush on the End
These pencil-type erasers are handy due to the pointed tip, which can be sharpened. They are good for cleaning up

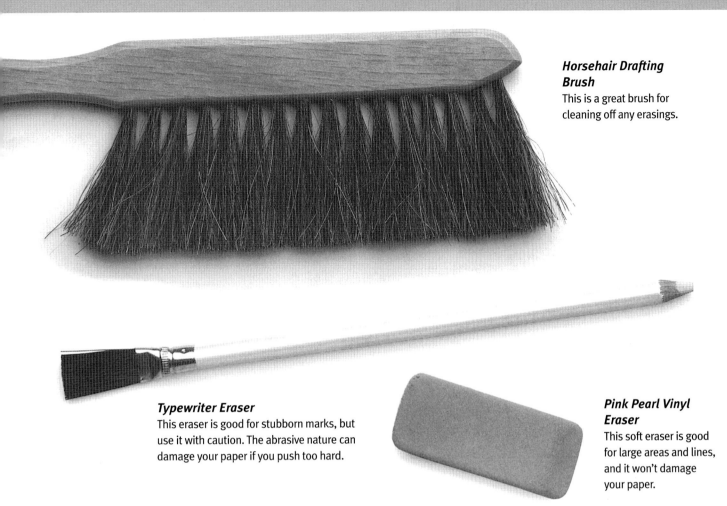

Horsehair Drafting Brush
This is a great brush for cleaning off any erasings.

Typewriter Eraser
This eraser is good for stubborn marks, but use it with caution. The abrasive nature can damage your paper if you push too hard.

Pink Pearl Vinyl Eraser
This soft eraser is good for large areas and lines, and it won't damage your paper.

edges and erasing stubborn marks, but their abrasive nature can rough up your paper. Use them with caution.

Horsehair Drafting Brush
These wonderful brushes will keep you from ruining your work by brushing away erasings with your hand and smearing your pencil work. They will also keep you from spitting on your work when blowing the erasings away.

Pink Pearl Vinyl Eraser
These erasers are meant for erasing large areas and lines. They are soft and nonabrasive, so they won't damage your paper.

Workable Spray Fixative
This is used to seal and protect your finished artwork. "Workable" means you can still draw on an area after it has been sprayed. It fixes, or sets, any area of your drawing, allowing you to darken it by building up layers of tone without disturbing the initial layer.

Drawing Board
It's important to tilt your work toward you as you draw to prevent distortion that occurs when working flat. Secure your paper and reference photo with a clip.

Ruler
Rulers help you measure and graph your drawings.

Acetate Report Covers
Use these covers for making graphed overlays to place over your photo references. They'll help you accurately grid your drawings.

Magazines
These are a valuable source of practice reference material. Collect magazine pictures and categorize them into files for quick reference. A word of warning: Don't copy the exact image. Many photographers hold the copyright for the work, and any duplication without their express permission is illegal.

The Five Elements of Shading

To draw realistically, you must understand how lighting affects form. There are five elements of shading that are essential to realistically depicting an object's form. If any of these elements is missing, your work will appear flat. However, with the correct placement of light and dark tones, you can draw just about anything.

But how do you know how dark is dark and how light is light? Using a simple five-box scale of values can help you decide on the depth of tone. Each tone on the scale represents one of the five elements of shading.

1 CAST SHADOW

This is the darkest tone on your drawing. It is always opposite the light source. In the case of the sphere, it is underneath where the sphere meets the surface. This area is void of light because, as the sphere protrudes, the sphere blocks light and casts a shadow.

Shading Creates Form
Notice how the five elements of shading on the sphere correspond to the tones on the value scale. Look for the five elements of shading in everything you draw.

2 SHADOW EDGE

This dark gray is not at the very edge of the object. It is opposite the light source where the sphere curves away from it.

3 HALFTONE

This is a medium gray. It's the area of the sphere that's in neither direct light nor shadow.

4 REFLECTED LIGHT

This is a light gray. Reflected light is always found along the edge of an object and separates the darkness of the shadow edge from the darkness of the cast shadow.

5 FULL LIGHT

This is the white area, where the light source hits the sphere at full strength.

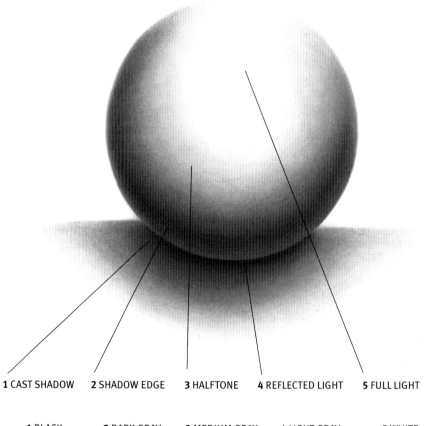

| 1 CAST SHADOW | 2 SHADOW EDGE | 3 HALFTONE | 4 REFLECTED LIGHT | 5 FULL LIGHT |

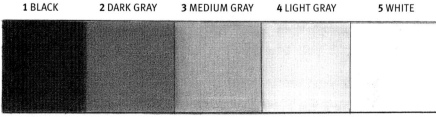

| 1 BLACK | 2 DARK GRAY | 3 MEDIUM GRAY | 4 LIGHT GRAY | 5 WHITE |

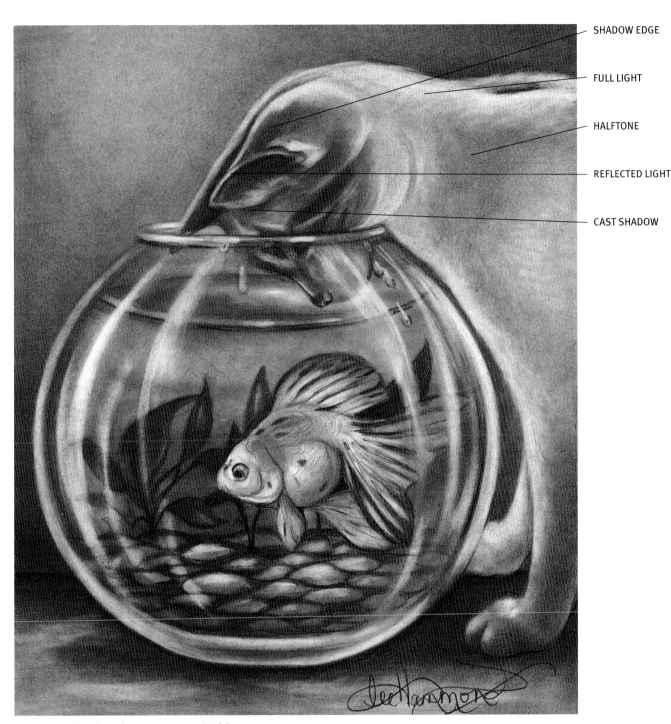

SHADOW EDGE

FULL LIGHT

HALFTONE

REFLECTED LIGHT

CAST SHADOW

Applying the Five Elements to Real Objects

To illustrate the importance of the five elements of shading, let's study this illustration. Looking closely, you will see the elements of the sphere on the previous page repeated throughout the drawing, not just on the cat. Reflected light plays a large role in creating the edges of the cat's head as well as the front of the legs. The edges of the fishbowl are created with reflected light that shines brightly against the darker background.

SHADE, DON'T OUTLINE

Look for the five elements of shading in all that you draw. Use shading in the background to create light edges on your subject. Without it, you will be forced to use outlines to differentiate your subject from the white of the paper, which can make things look cartoonlike.

Blending Technique

Proper shading requires smooth blending. To create smooth blending, you must first learn to use your tools and apply the pencil lines properly. If the pencil lines are rough and uneven, no amount of blending will smooth them out.

Apply your pencil lines softly and always in the same direction. Build your tones slowly and evenly. Lighten your touch gradually as you make the transition into lighter areas. Smooth everything out with a blending tortillion, moving in the same direction you used to place your pencil tone. Begin with darks and blend out to lights.

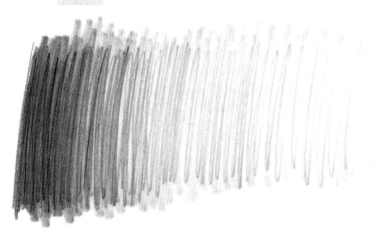

Incorrect Blending
This sample shows poor pencil application. The scribbled lines look sloppy, and a tortillion wasn't used for blending.

Keep Lots of Tortillions on Hand
Always use a fresh tortillion for the light areas. Don't be tempted to use the same ones over and over again to conserve. They are nothing more than paper wrapped into a cone shape and are inexpensive. I buy them by the gross so I never have to search for a clean one when I need it.

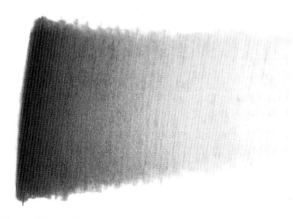

Correct Blending
Apply the lines closely, and then, in an up-and-down fashion, fill them in. Add tone until you build up a deep black, then lighten your touch and gradually get lighter as you move to the right.

Blend your values with a tortillion, using the same up-and-down motion you used with the pencil. You do not want to see clear distinctions between where one tone ends and the next begins. Lighten your touch as you move right and gently blend the light area into the white of the paper until you can no longer tell where it ends.

Hold Your Tortillion at an Angle
For even blending and to keep the end of your tortillion sharp, always hold it at an angle. If your end becomes blunt, poke a straightened paper clip from the inside through the top to straighten it out.

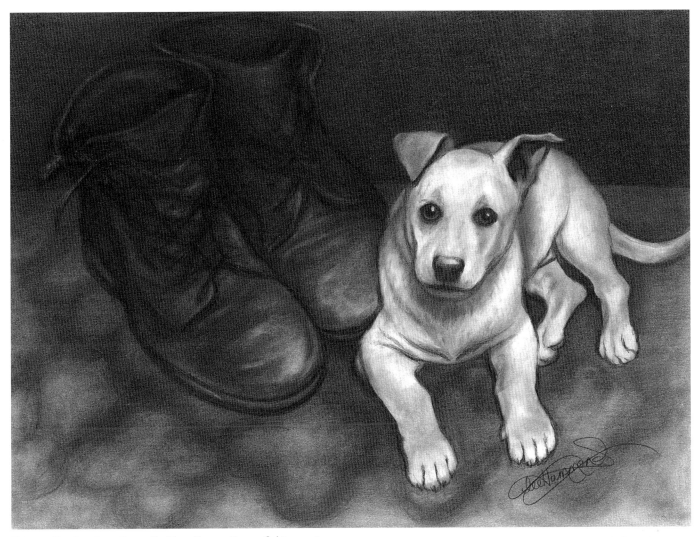

Strong Contrasts + Smooth Blending = Powerful Impact

This is a rendering of a puppy my son-in-law found in Afghanistan while serving in the U.S. army. The soldiers kept Zor-Mutt after they found him, offering him safety within their military dwelling. The white puppy becomes the focus of the drawing because of the dark tones surrounding it. The darkness of the drawing also sets the tone of a dreary atmosphere inside a military camp.

The army boots subtly depicted within the shadows offer a size relationship to the dog, telling you just how small he is. This lends a feeling of innocence and helplessness to the puppy. The use of deep tones, combined with smooth blending, makes this drawing look very realistic.

CREATE A MIDDLE GROUND

When you blend, you create a middle tone. You are then free to add darks or lights by applying tone or lifting it out.

Graphing Technique

Graphing is the best way for a beginning artist to learn to draw shapes accurately because it allows you to break down any subject—no matter how complicated—into small, manageable pieces.

When you place a grid of perfect squares over your reference photo, each square will isolate shapes, making them easier to draw. It is easier to draw this way because the shapes within each square become "nonsense" shapes that are less complicated to reproduce than taking on the "big picture" all at once. Instead of thinking about how to accurately draw a dog's leg, for example, all you need to do is draw the shapes you see within each of the boxes, and they will eventually combine to form a dog's leg. It's not much different than putting together a puzzle!

Let's look at an example. This photograph of Milo, a cocker spaniel mix, has been divided into even increments with a grid of one-inch (3cm) squares. I enlarged the original photograph on a photocopier to make it bigger. Next, I used a permanent, fine-point marker and a ruler to draw the grid directly on top of the copy. Then I lightly pencilled another grid onto my drawing paper and drew the shapes that I saw within the reference photo, square by square. If you draw just the shapes you see within each square, one square at a time, the line drawing of the dog will appear. I was able to draw this dog accurately, much more accurately than by drawing freehand.

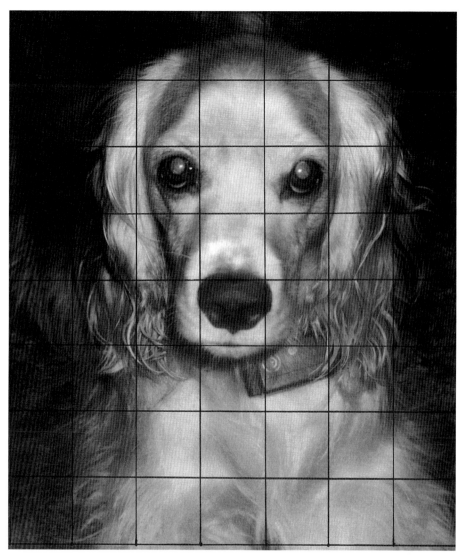

Graphing a Photo
Dividing a photograph with a grid makes it easier to draw accurately because you focus on only one part of the subject at a time instead of trying to draw the subject as a whole. This photocopy of Milo has a grid of one-inch (3cm) squares drawn on top.

This graphing technique also makes it easy to enlarge or reduce a drawing based on a photo. To enlarge the image, simply make the grid on your drawing paper of a larger scale than the one on the photo. Reducing is done the same way, only you make the grid on your drawing paper of a smaller scale.

Remember to always draw the grid lines lightly on your drawing paper because you'll need to erase them later as you complete your drawing.

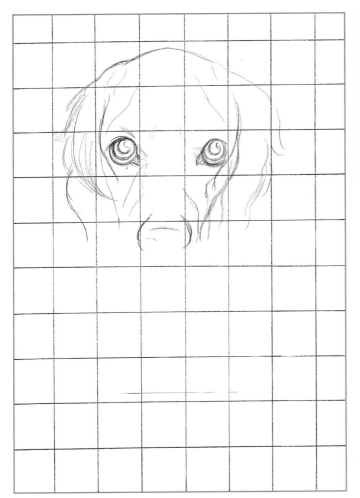

Make a Line Drawing

Count how many one-inch (3cm) squares are required to capture the image. This one requires six squares across and nine squares down. Lightly draw a grid on your drawing paper and begin a line drawing of the dog. Draw one square at a time, looking only at the shapes within that box. An accurate line drawing of your subject matter will appear.

Save Your Finished Line Drawing

Finish the line drawing of Milo and save it for a project later in the book. Your drawing should look like mine when you are finished.

MAKE A LIGHT GRID

Remember to draw your grid very lightly on your drawing paper so it can be easily erased later. The grids in this book are printed darker than you should draw them, so they are easy for you to see.

Line Drawing Practice

Lightly draw a grid of one-inch (3cm) squares on your drawing paper for each of the photos provided. Then complete the line drawings. Each of them will be used to complete an entire drawing later in the book.

All drawings begin with accurate line drawings such as these. They are the foundation for the blending and shading we will apply later. No shading should be applied until this phase is as accurate as you can get it. Changes are difficult to make once shading has been added, but it is easy to alter at this early stage. Don't obsess over the details at this point and overdo your lines; you'll have the chance to fully develop your drawings later.

Remember, you can enlarge or reduce your drawing by adjusting the size of the squares you place on your paper. As long as you make the boxes perfectly square, the rest is all relative.

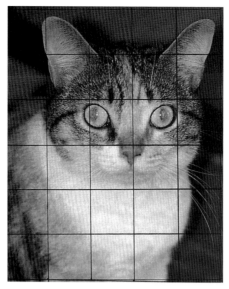

Reference Photo
This photo of Mindy, a Tortoise Shell/Calico mix, has been divided into five squares across and six squares down.

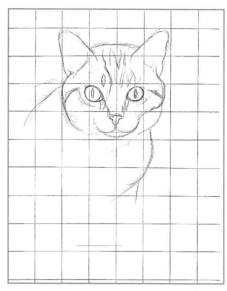

Finished Line Drawing
I chose to crop the image to create a head-and-shoulders portrait.

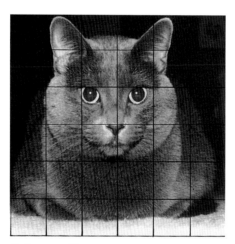

Reference Photo
This photo, divided into six squares across and down, will give you practice drawing a whole cat in a simple pose. This cat is a Domestic Short hair.

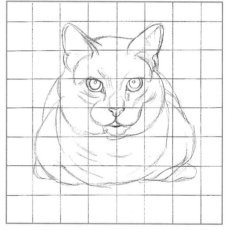

Finished Line Drawing
In my family, we call this pose a "platter cat" because it resembles a Thanksgiving turkey!

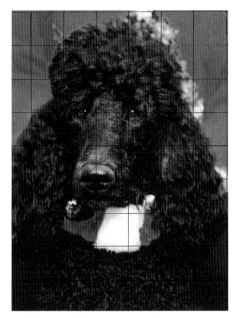

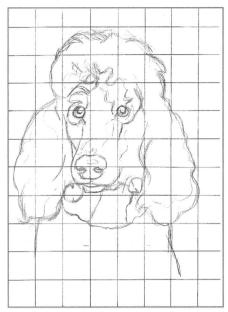

Reference Photo

This standard poodle will be a great exercise to learn how to draw curly hair. For now, just concern yourself with the overall shapes. This photo is divided into seven squares across and nine squares down.

Finished Line Drawing

The important shapes such as the facial features and the overall shape of the fur have been captured. Small details and hair direction will be applied later.

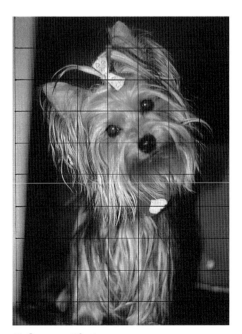

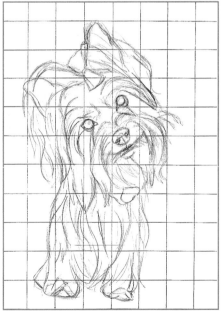

Reference Photo

This little Yorkshire terrier offers us the challenge of drawing long, silky hair. This photo is divided into seven squares across and ten squares down.

Finished Line Drawing

This line drawing looks more complicated than the others. I used the grid to help capture the many layers of long fur and the fur's direction.

3 Facial Features

Animals have personalities just like people do, and their emotions can be clearly seen through their expressions. Since our pets cannot talk, they communicate with us through their faces and body language.

The eyes of an animal give life to your artwork when they are drawn well. As with people, the personality and soul are conveyed through the eyes, and they will be one of the most important aspects of any portrait you draw. In this chapter you'll also learn how to draw a variety of other facial features—nose, mouth and ears—to complete your pets' unique expressions.

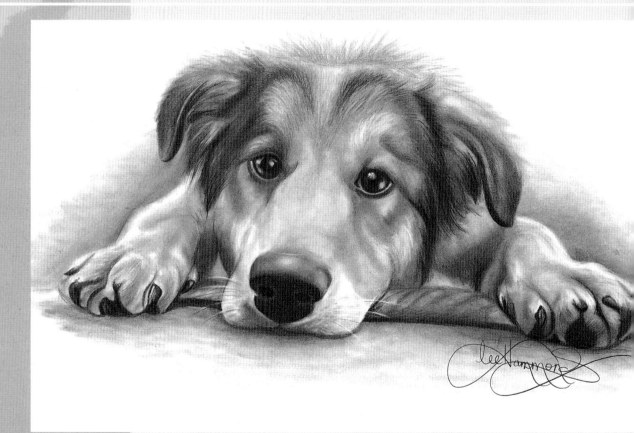

Those Puppy Dog Eyes
This is my newest family member, Misty. She is a very big girl, being a Great Pyrenees mix. Even though she is big, she is still a puppy, which I think comes across in this drawing. You can see the youthful innocence in her eyes, and the pose represents a baby that has clearly worn herself out playing.

MISTY
11" × 14" (28CM × 36CM)

The Many Moods of Animals

They may not be able to say exactly what's on their minds, but, just like humans, animals can say quite a bit with a facial expression. Some animals, such as the basset hound, have very overt expressions, while other animals, like the rabbit, are more subtle. Conveying the moods of your pets will require that you understand what it is about their features that is "giving away" their mood.

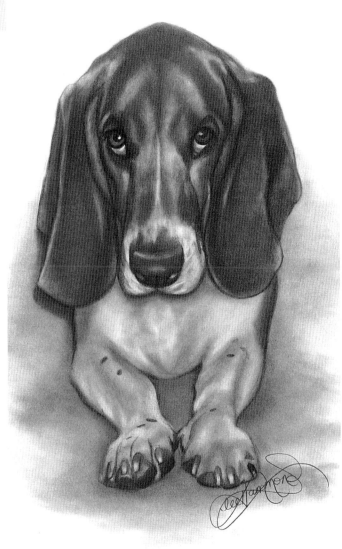

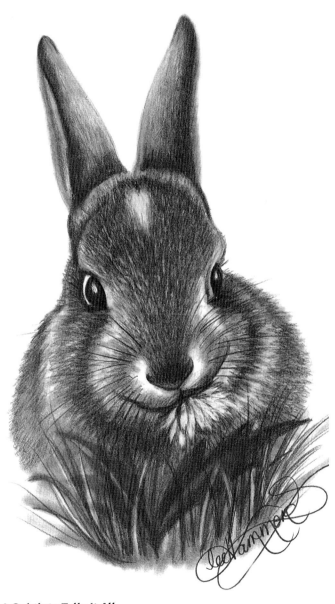

The Eyes Have It

Basset hounds are known for their expressive eyes, long faces, short legs and floppy ears. In this drawing, it looks like this little pooch is apologizing for something. Her eyes appear sad and humble. This type of emotion is essential to convey in good pet portraiture.

A Subtlety Tells It All

Rabbits don't have the wide range of facial expressions that a dog or cat would have. They are mostly known for their wiggly noses. However, when they eat, they cutely turn their mouths to the side. This drawing captures that angle and reveals a soft, gentle personality. Look for subtleties like this when you draw.

Drawing Fur

Let's begin by learning how to draw the fur that will surround the features. You can make it look real by using shading and blending then adding pencil strokes to mimic the look of the fur. The lines you create with the pencil must be consistent with the length and direction of the hair. To try to make long fur with short pencil lines will not work.

What Not to Do
These lines are too hard and too straight. To draw hair or fur, you *must* use a quick stroke, one that becomes lighter and tapered on the end.

Correct Lines
This is what tapered lines look like. When you flick your wrist as you draw, the lines will soften at the end. Also, there is a slight curve to them, which also makes them look softer.

For Long Hair
Apply quick strokes, always going in the same direction as the hair is growing. Keep applying until it "fills" and becomes the color you want. Notice how some of the hairs start to overlap one another.

Blend
Blend it all out, still following the direction of the hair growth.

Lift Out Lighter Strands
With a kneaded eraser molded into a point, lift out some lighter hairs. This is what makes the hair look like it is in layers and has fullness.

For Short Hair
Short hair is done the same way, only with shorter strokes. A quick stroke with the pencil is essential.

For Light, Smooth Fur
For the type of fur that you might find on a light, shorthaired animal such as a yellow Labrador retriever, you will draw mostly with a dirty tortillion instead of a pencil. The look of individual hairs is not as visible. Again, lift out the lighter hairs with a kneaded eraser.

BUILD LAYER BY LAYER

When the hair or fur doesn't look right, it's usually because you stopped before you were really finished. Devote the proper time to the rendering of hair—it *must* be built up in layers, and it may take many!

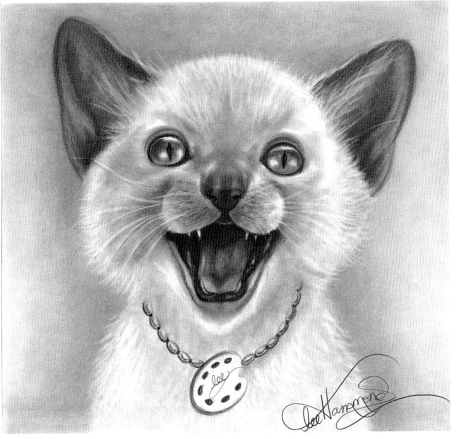

Let Dark Shading Create Light Edges

This kitty has a surprised look, with its wide-open eyes and mouth. You can almost hear it meow! Because this is a white cat, it was drawn with shading instead of hard outlines, which would look cartoonish. Dark shading around the cat's light-haired head and body creates soft edges, making it look much more realistic. The light areas were then lifted out of the shading on the cat's fur.

BLEND, EVEN FOR WHITE

Regardless of the type and color of fur you are drawing, it is important to blend everything to remove the harsh, unnatural white of the paper. Even white fur is never pure white. By creating a blended tone, you can then lift out the light areas with a kneaded eraser. Consider this as drawing in reverse. You are not really erasing; lifting out is actually the process of "adding" light tones. The kneaded eraser is just another form of drawing tool.

For Short Fur, or None at All

These two friends look like they should be ironed! They are examples of extremely short fur, or no fur at all. In a case like this, concentrate on rendering the wrinkles instead. If you look closely at the wrinkles on the shar-pei and the sphynx, you will see the five elements of shading in each roll. Treat these areas as individual cylinders as you draw them.

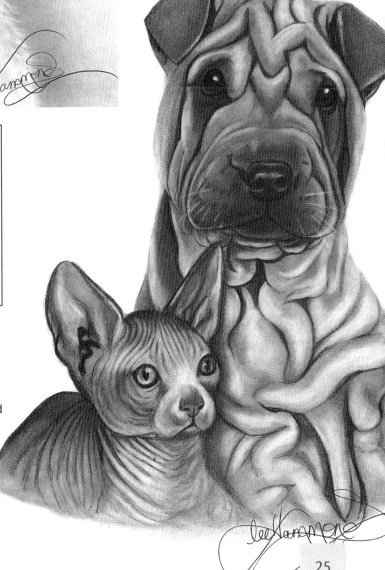

Drawing the Face of a Cat

By drawing a close-up of an animal, you become familiar with the characteristics of its species and particular breed. Most cats' features will look similar even among the different breeds. An exception to this would be a Persian, whose flat face changes the way the features look. Try to memorize the generalities of the facial features of different animals so you know what to look for when you draw. You will then recognize the shapes that are repeated and always seen.

This is a simple head-and-shoulders study of my cat Mindy. It is the finished drawing created from the photo on page 20 in chapter two. Mindy is a small kitty with huge eyes. She seeks complete eye contact with people at all times. Because of that, she is the perfect subject to practice on for drawing cat features.

The following pages will show you how to create Mindy's facial features step by step. Take the line drawing you created and carefully remove the grid lines with your kneaded eraser, leaving just the line drawing of the cat. Then work your way around Mindy's face, concentrating on one feature at a time.

Cat Eyes

I always start any type of portraiture, whether it is a person or an animal, with the eyes. The eyes typically capture the personality and expression of the subject. If the eyes are not done well, your drawing will be off the mark.

CORRECTING RED-EYE

When drawing pet portraits from photos, you will often encounter red-eye. Animal eyes are extremely reflective, and the glare of the camera flash can cause the lens of the eye to glow red in the pictures. To remedy this problem in your artwork, make the pupil totally black. Then use the "half in the pupil, half in the iris" placement for the catchlights in your drawing.

1 Check the Line Drawing

Make sure the line drawing is accurate. Be sure that the pupils are centered within each eye. A cat's pupils will change according to the light. In low light, the pupils look round. In strong light, they nearly close and become slits. These pupils are somewhere in between.

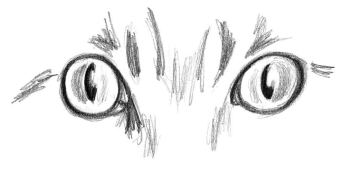

2 Darken the Pupils and Place the Catchlights

Darken the outlines of the eyes. Add some tone to the iris (or colored part) of the eye, and fill in the pupil as black as you can. Leave a thin area of light around the pupil. Because the pupil is actually a "hole," not a black dot of pigment, the edges of the pupil will reflect light around it. Also leave an area for the *catchlight*—the reflection of the camera's flash or a surrounding light source. It should generally be located in the same area for both eyes, and it is always placed half in the pupil and half in the iris. Start placing some of the fur markings around the eyes.

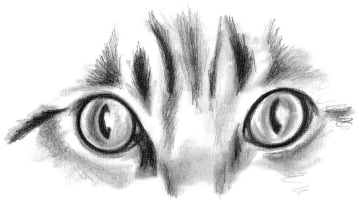

3 Blend and Lift Out

Using your tortillion, gently soften the tones inside the eyes. The smooth tones will make the eyes look shiny. With a kneaded eraser, lift out the catchlights some more. Lifting out light makes it look more natural and reflective. With the tortillion, soften the fur markings and reduce the white of the paper. Replicate the short fur with short, quick strokes of your pencil.

Cat Nose and Mouth

Once the eyes are complete, you can continue the drawing by moving on to the nose and mouth.

QUICK LIFTS FOR THIN WHISKERS

The quicker the strokes you use to lift out the tone with your pointed kneaded eraser, the thinner the whiskers will be. Don't get frustrated with this process if you seem to lift out too much; it takes practice. If a whisker seems too thick, just add tone on either side of it and blend to narrow it.

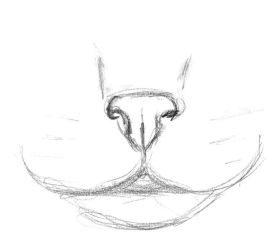

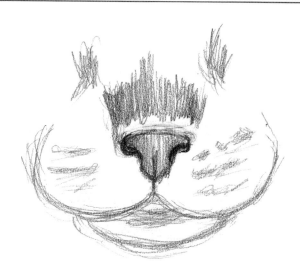

1 Check the Line Drawing

Check your line drawing and make sure that the outlines of the nose and mouth area are drawn accurately.

2 Add Tone and Whisker Marks

Add some tone to the nose and to the area above the nose. Leave a little light edge between the two. Add the little marks on the face where the whiskers grow.

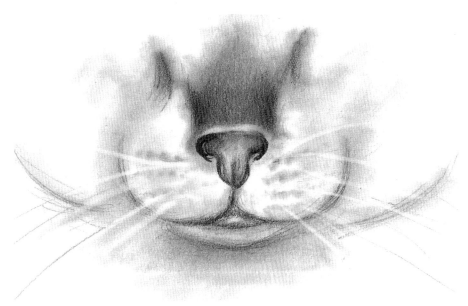

3 Blend and Add the Whiskers

Blend the nose and surrounding areas with a tortillion. The shading is what makes the mouth area stand out. With your kneaded eraser formed into a sharp point, quickly lift out thin lines for the parts of the white whiskers that overlap the face.

Cat Ears

Now it is time to add the top of the head and the ears. A cat's ear is fairly simple; it looks like a triangle with hair coming out if it.

TO FINISH THE CAT

To totally finish the drawing shown on page 26, add some shading behind the cat to create the illusion of a background. Create the back and chest, following the finished example. Always apply the pencil lines consistently with the direction the hair and fur grows. Then blend it with a tortillion. You can actually draw with a dirty tortillion in soft areas such as the background and chest area. This reduces the look of pencil lines and gives a much smoother impression.

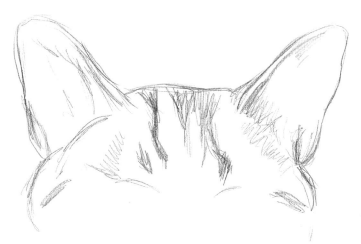

1 Check the Line Drawing

Check your line drawing for accuracy in the shapes. Make sure you have drawn the edge of the inner ear, which indicates the ear's thickness. Without it, the ear would look as thin as a piece of paper.

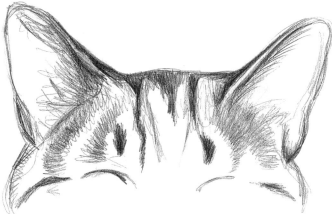

2 Pencil the Fur

Pencil short strokes to represent the markings and texture of the fur. Follow the length and direction of the fur's growth. The length of your lines should represent the length of the fur. Extend some longer strokes into the ears.

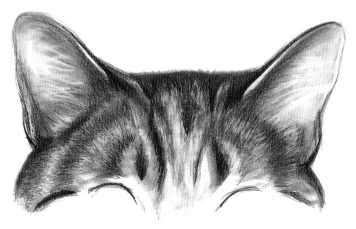

3 Blend the Tones and Reapply Textures

Smoothly blend the tones with a tortillion. Reapply quick pencil lines to strengthen the darkness and texture of the fur. Pay attention to the patterns of the fur. To create some small light hairs, use a quick flick with a pointed kneaded eraser.

Drawing the Face of a Dog

This is the fully developed drawing of the line drawing on page 19. We will complete this drawing the same way we did the cat, tackling one feature at a time. Carefully study each of the facial features and memorize their characteristics as you go. Despite varying breeds, the overall structures will be similar, even if the size changes.

The personality of this dog is clearly coming through in this drawing. You can tell that Milo was a very gentle dog just by the way he looked at people. (Unfortunately, Milo was hit by a car and passed away.) Using your kneaded eraser, carefully remove the grid lines from the line drawing you created. Be sure not to accidentally erase any of your line drawing.

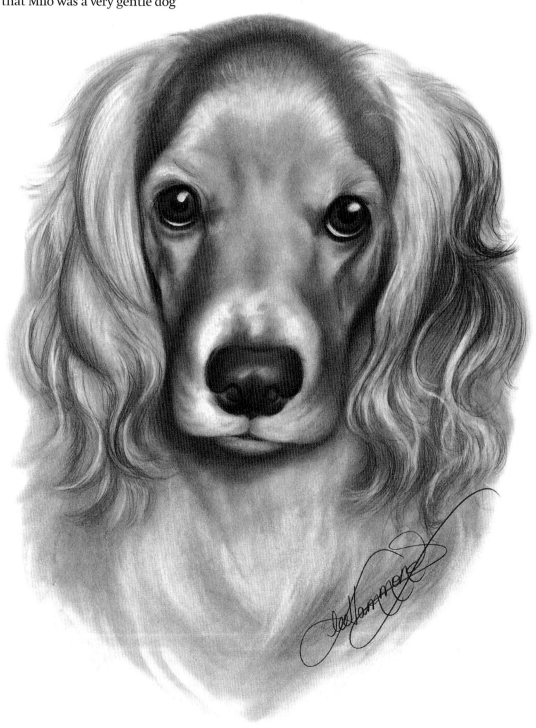

Dog Eyes

As you render the eyes, realize that, unlike a cat's, the pupils of a dog will always be round. Their shape is not altered by extreme light.

1 Check the Line Drawing

Check your line drawing for accuracy. Make sure the pupil is in the center of each iris. Also be sure to place the catchlights half in the pupil and half in the iris. The eyes of this dog have a little bit of white showing below the iris. Don't accidentally fill that in.

2 Start Adding Tone

To correct the red-eye from the camera flash, fill in the pupils as black as you can, leaving the catchlights. Add tone to the iris to create the illusion of a brown eye. Also add some tone to the area between the eyes and along the sides of the muzzle and the head. These tones define the shape and contour of the dog's face.

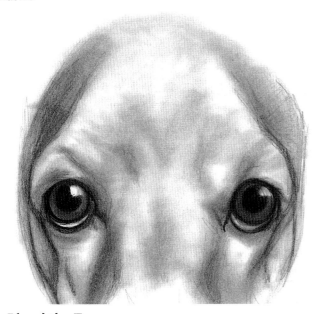

3 Blend the Tones

With the tortillion, smoothly blend the tones. Lift out the catchlights to make the eyes appear shiny and wet.

Dog Nose and Mouth

Let's continue the drawing of Milo by adding the nose and mouth. What you learn from this exercise will be repeated in other dog drawings you encounter later. Study the shape of the nose in particular. Look at the way the top of the nose curves down into the nostril area. Compare it to the nose of the cat. The cat's nose is much flatter, while the nose of a dog often protrudes. With both dogs and cats, there is a definite separation that creases and divides the nose down the middle.

Much like other species, there will be anatomical variations according to the breed.

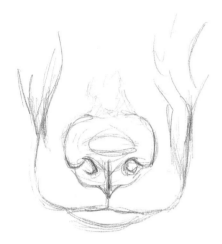 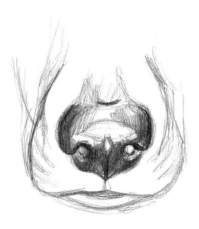 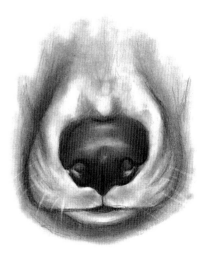

1 Check the Line Drawing

Make sure your line drawing is accurate. Do not place any tone until you are happy with the overall outline.

2 Fill In the Darkest Areas

Pencil the darkest areas first; in this instance, the bottom and sides of the nose. Leave a highlight area on the tip of the nose. This is what will make the nose look moist and reflective.

3 Blend and Lift Out

Smoothly blend the tones. Make sure the dark areas of the nose remain very dark by reapplying the tones. Apply more tone to the areas on each side of the muzzle and blend. Contrast is very important when depicting form. Can you see how the darks seem to make the muzzle protrude and look three-dimensional?

With a kneaded eraser, lift out the light whiskers and the spots where they originate.

Dog Ears

To complete the drawing of Milo, we need to add his long, silky ears.

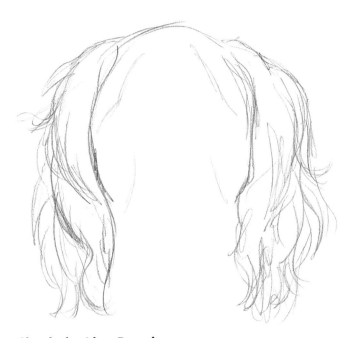

1 Check the Line Drawing

Check your line drawing for accuracy. It should describe the outside edges of the ears and the layers and direction of the long hair.

2 Add Long, Layered Strokes

With long strokes that represent the length of the hair, add pencil lines in layers. Follow the direction in which the hair is growing, and curve the lines to help create the gentle waves.

3 Build the Layers

It takes many layers to accurately depict the fullness of hair. Don't stop too soon. Once the layers have been built up, blend them to remove the white of the paper. Otherwise the paper will show through. This will make the hair look thin, like you are seeing through to the background.

Once the areas have been blended, add more dark pencil layers. With a kneaded eraser, lift out the highlights in the hair.

Other Furry Faces

The facial features of other furry pets are very different from those of cats and dogs. Compare the following illustrations of guinea pigs and rabbits. As you can see, they are very similar in their anatomical structure and shape. It is obvious that they are genetically related.

Close observation also reveals how much their eyes, noses and mouths resemble one another. The main difference is in the ears. But, you can see from my drawings that not every rabbit is the same. Each of the bunnies has a different type of ear.

GRAB YOUR PENCIL!

Should you want to try drawing the cute little creatures on these pages, you can use one of two techniques. If you have good free-hand skills, lightly sketch their basic shapes on your drawing paper and develop them from there. If you want to graph them out and work only on isolated areas at a time, make a grid of one-inch (3cm) squares on acetate with a permanent marker and use it as an overlay. Or, you can draw your grid on regular paper and have a photocopy store print it for you on acetate.

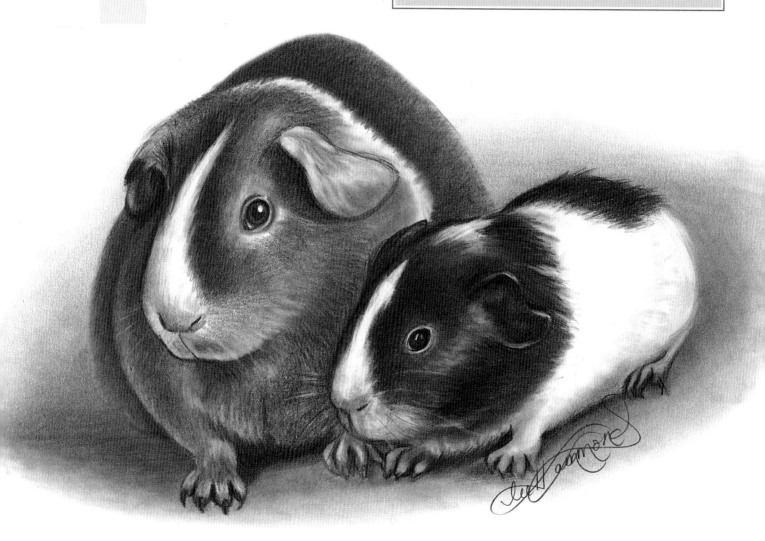

Guinea Pig Characteristics
Because a rodent's face is smaller, its nose and mouth are not as distinct as that of a dog or cat, and its small, dark eyes look like dots. It is harder to differentiate between the pupil and the iris in a rodent's eye.

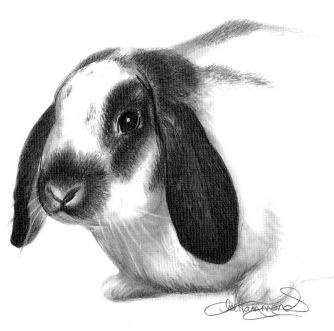

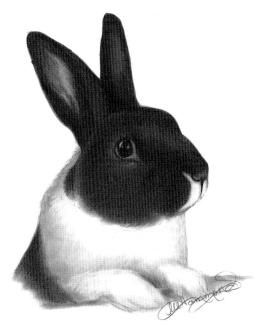

The Guinea Pig's Close Cousin

This rabbit closely resembles the guinea pigs. The faces are very similar, and their eyes are very much the same. If you look at only the face and ignore the ears, they are almost identical. This rabbit is called a "lop ear" because the ears hang down along its face.

Standard Bunny Ears

This rabbit has the ears we all recognize: They stand straight up. Aside from that, this bunny looks a lot like the guinea pig as well.

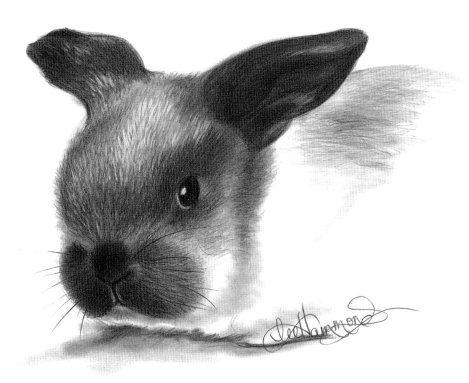

A Different Kind of Rabbit

This rabbit has a flat face, which differentiates it from the others. Its features vary from other rabbits in the same way the Persian, who also has flat features, differs from the other various breeds of cat.

Mouse Face

I have had mice and rats as pets for as long as I can remember. I think this is the first time in my life that I haven't had a rodent in my household. I love their little faces and delicate features.

To draw this mouse, which came from a magazine ref-erence, we'll use the same techniques as in the previous exercises. Always begin with an accurate line drawing, and then continue with the addition of pencil lines for tex-ture, blended tones, and, lastly, lifted-out light.

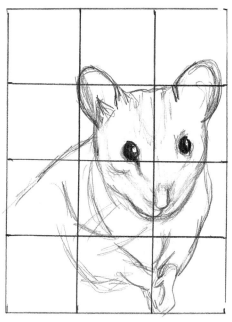

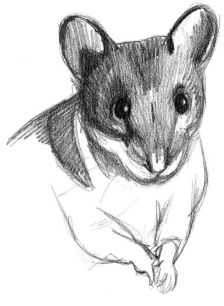

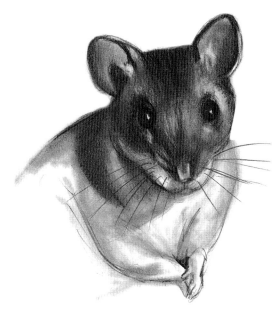

1 Make a Line Drawing
Re-create this line drawing, then remove the grid lines. Start filling in the eyes, reserving two tiny spots for the catch-lights.

2 Fill In the Eyes and Start the Fur
Continue filling in the eyes until they are extremely dark. The catchlights will make them shine. Start applying the tones and textures of the fur, following the direction of growth.

3 Blend and Finish the Details
Blend the drawing with your tortillion, and reapply the pencil to create texture and contrast. When you blend, the catchlights of the eyes should receive very little tone. You want them to con-trast the blackness surrounding the catchlights, giving the eyes form. Lift out the highlights and light hairs with a kneaded eraser. Add the whiskers with quick, tapered pencil strokes.

Rabbit Face

Now let's draw this young bunny's face, also based on a magazine photo.

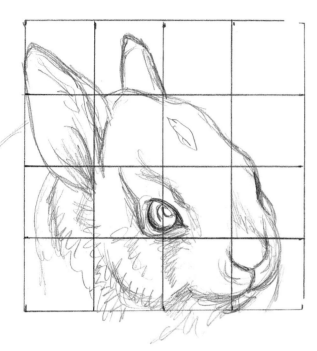

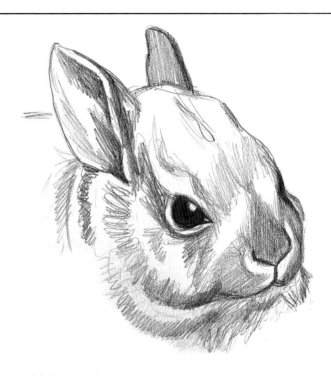

1 Make a Line Drawing

Re-create this line drawing, then remove the grid lines.

2 Add the Darkest Tones

Fill in the eyes first. Even though the eye is so dark you cannot easily see an iris, put one in anyway. Although it is barely visible, it keeps the eye from just looking like a black spot. Include a catchlight half in the pupil and half in the iris.

Continue adding tone to the darkest areas of the face, following the direction of the fur and making the pencil lines the length of the fur.

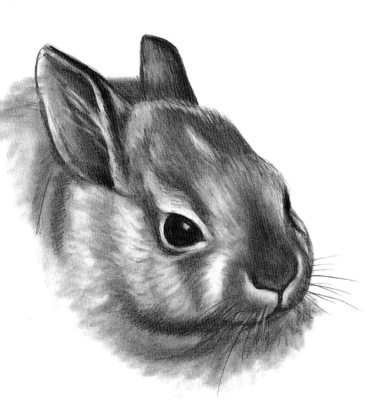

3 Blend and Reapply Darks

Blend the tones with your tortillion. Reapply the darks in the fur with quick lines to increase the contrast and intensify the texture. Lift out the highlights and light hairs with a kneaded eraser. Apply the whiskers with quick, tapered pencil strokes.

4 Realistic Fur

Once you have mastered the art of drawing hair and fur correctly, you'll be surprised at how your drawings will come to life. What once looked like an outlined cartoon will now become a lifelike rendition that leaps off the paper.

In the previous chapter we began to learn the importance of building layers of pencil strokes and lifting out light areas when rendering hair and fur on animal faces. Now we will carry those techniques to the rest of the body.

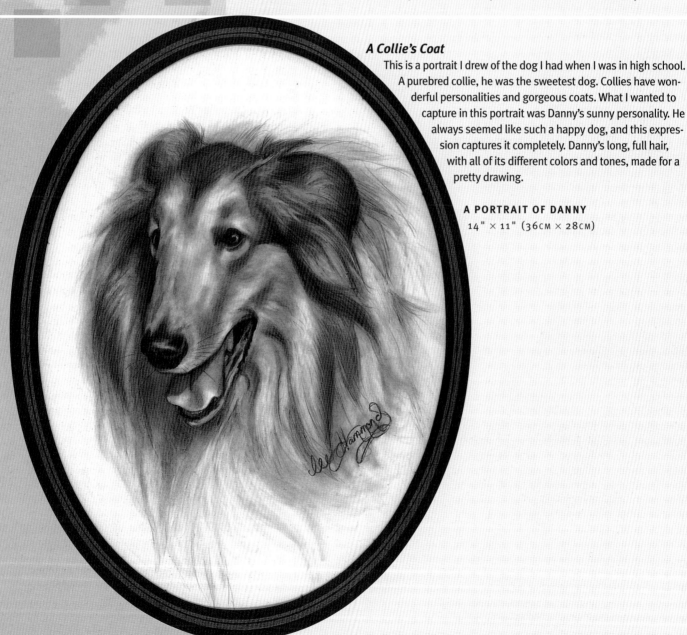

A Collie's Coat

This is a portrait I drew of the dog I had when I was in high school. A purebred collie, he was the sweetest dog. Collies have wonderful personalities and gorgeous coats. What I wanted to capture in this portrait was Danny's sunny personality. He always seemed like such a happy dog, and this expression captures it completely. Danny's long, full hair, with all of its different colors and tones, made for a pretty drawing.

A PORTRAIT OF DANNY
14" × 11" (36CM × 28CM)

Drawing Fur

To draw a portrait such as the one of Danny on the opposite page, you need to have a very good understanding of how to draw hair and fur. Flip back to pages 24 and 25 to refresh your memory. As I mentioned before, you must create many, many layers of overlapping pencil strokes to make the fur look silky, full and authentic. It is very important to follow through and not quit too soon. Give the drawing all of the time required, and you will be thrilled with the results.

What was not covered previously is how to draw wavy or curly fur, which is a little more complex. The pencil strokes must curve to match the waves of the hair. It will take practice to learn to control your pencil in a curved stroke.

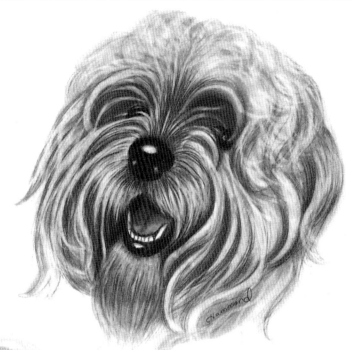

Each area of hair must be treated individually.

Apply quick pencil strokes following the hair's natural curve.

Blend out with a tortillion. Create curls and wisps.

Add more dark strokes with a pencil. With a kneaded eraser, lift out highlights everywhere the hair curves. Repeat to build curly layers.

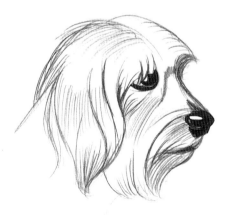

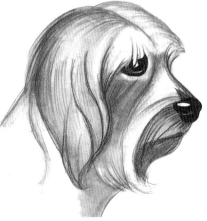

Start with an accurate line drawing, then add pencil lines in the direction the hair is going. Fill in the nose and eyes, and use quick, curved strokes to create the dog's form. Remember to leave the catchlights white.

Blend everything out to a smooth gray tone. Be sure to blend in the same direction as the pencil lines.

With your kneaded eraser in a razor edge, use quick strokes to lift out the long hair. Go back and forth between lifting lights and reapplying darks until it looks shaggy and full.

Short Fur

Let's begin with a full portrait of a shorthaired Russian Blue mix cat. Use the line drawing you created of the gray cat on page 20 and render it into a finished drawing.

A good photograph, such as this one of CT, is essential, especially for rendering fur. This photo was perfect for many reasons. For one, it is nice and clear, and I am able to see the texture of the fur and all of the facial features distinctly. The dark background makes the cat stand out, so its contours are plain to see. Also, the eyes are not affected by the red-eye commonly resulting from a camera's flash.

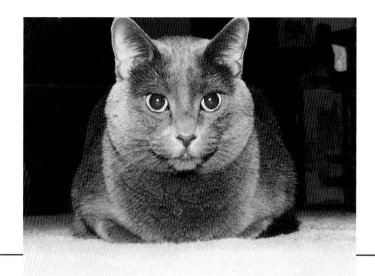

Reference Photo

WORK FROM LARGE REFERENCES

Never try to work from a photo that is too small. You need to be able to see the fine details of your subject. If you resort to guesswork, the consequences could be disastrous. In addition to referring to the original photo, I always enlarge my photos on a color photocopier or a computer to aid in my drawing.

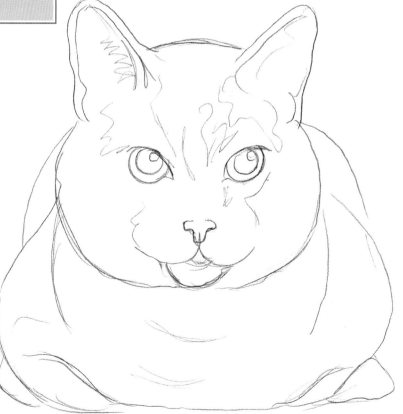

1 Remove the Grid Lines

Check the accuracy of the line drawing you created for this cat on page 20. After you erase the grid lines from your paper, your drawing should look like this. Be careful not to remove any of the important lines of the drawing as you erase the grid.

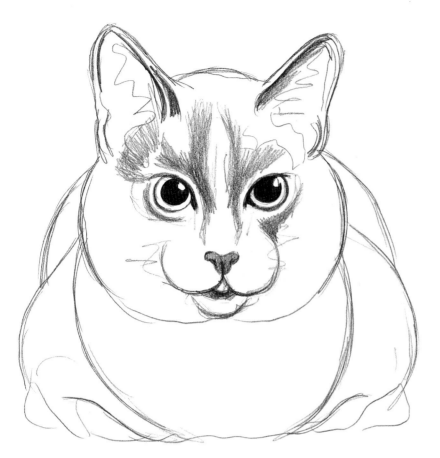

2 Begin With the Eyes

Start your portrait with the eyes. Although the photo makes the pupils look a bit hazy, make them pitch black. Instead of placing the catchlight in the center of each eye, move it to the upper right. This helps the eyes appear to look directly at you.

Start placing the darkest tones around the eyes and on the nose and mouth.

3 Draw the Darkest Tones of the Fur

Build up the layers of fur, starting with the darkest areas first. This will be inside the ears and on the cat's sides. Remember to use very short strokes to replicate the length of the fur. Use very quick strokes so the lines will taper at the ends.

4 Build Up the Fur Layers

Build up the layers of fur to create the depth of tone you need. At this stage, blend the entire cat to remove the white of the paper. Then reapply the dark hairs for texture, and begin lifting out the light hairs with a kneaded eraser. Continue building fur layers with both the pencil and your kneaded eraser.

5 Don't Stop Too Soon

Continue layering pencil strokes with the pencil. Then blend them out with the tortillion. With the kneaded eraser, lift out lights until you are satisfied. The darks and lights on the fur are key to creating the cat's form. When your drawing is completed, the texture of the fur should look soft and touchable. It is worth the time invested creating all of the layers.

Add such details as the whiskers and the very subtle tone on the whites of the cat's eyes to remove the harsh white of the paper. Soften the catchlights with a little lifting. Place a horizon line behind the cat to make it look like it's sitting on an actual surface, not floating in space.

Long Fur

Go back to the line drawing you created of the Yorkie on page 21, and follow this demonstration to develop the cute little pup. This exercise will give you a lot of practice rendering long hair, as well as hair in a variety of colors. This puppy is a tricolor of black, silver and brown. Since we are drawing in shades of gray, we must create the illusion of different tones purely through the application of dark and light. Obviously, the black areas of the fur will be the darkest, the brown areas will be the middle tones, and the silver will be the lighter tones.

Reference Photo

1 Remove the Grid Lines

Check the accuracy of the line drawing you created for this dog on page 21, then erase the grid lines. Make sure you are happy with the overall shapes before you erase. This drawing also helps you see the many hair layers and divisions.

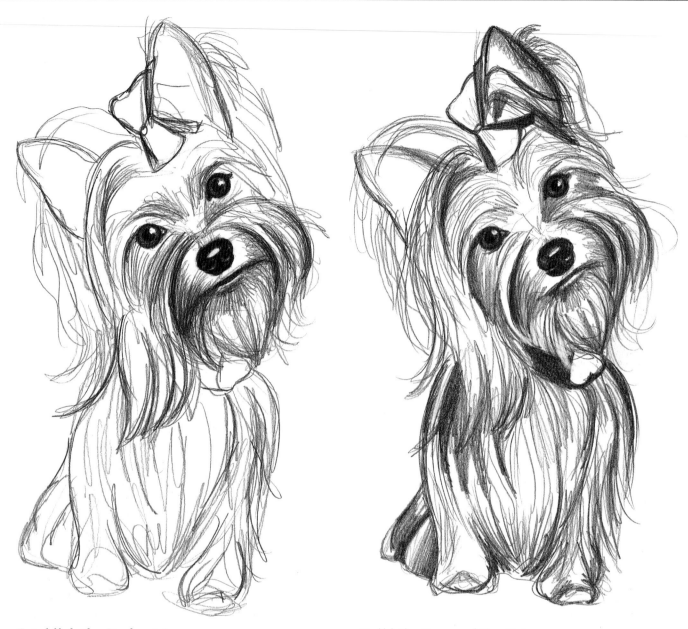

2 Establish the Darkest Areas

As always, begin with the eyes, correcting the slight red-eye and adjusting the catchlight. Fill in the pupil as dark as you can. I have moved the catchlight over to the right to help set the gaze of the eyes.

Now move on to the darkest areas. Fill in the nose as dark as you can, being careful to leave a spot for the highlight. With long pencil strokes, start developing the darkest areas of hair around the mouth.

3 Build the Tones of the Hair

Continue developing the darkest tones of the hair around the eyes, mouth and ears. Then begin working your way down the rest of the body. Carefully study the reference photo as you work, and note the hair direction. Build up the layers with quick strokes, curving them as necessary to create curls and waves.

4 Let the Darks Create the Lights

Continue building the dark areas until they actually create the surrounding lighter areas for you. When you have created the depth of hair that you need, blend the entire dog with your tortillion. This will create the middle tones of the hair.

USE LONG, CLOSE STROKES FOR LARGE AREAS

When filling in a background as large as this, it's important to make it very smooth. Sketchy pencil lines in the background will detract from the main attraction (your pet) in the foreground. Use long strokes to cover large areas, and apply the pencil lines very close together. Short, little strokes will overlap and cause a mottled appearance.

5 Lift Out the Lights and Add a Dark Background

Use a kneaded eraser to lift out the light hair and highlights. This is not a quick, one-step process. I usually go back and forth between the pencil and the eraser many times to create a believable texture. Trust your own judgment as to when you have layered enough.

To make the drawing more dramatic, create a dark background. Use a ruler to create a horizon line, representing the floor. Then create a border box to frame the dog. Carefully fill in the area within the border and blend it smooth with a tortillion. The dark background makes the lightness of the dog stand out. Establish the floor by making it darker than the rest of the background.

Curly Fur

Now take the line drawing you created of Nia, the standard poodle on page 21. Her tight curls are a perfect project for learning how to develop curly fur. We'll also discover how to make her hair look three-dimensional instead of flat—a real challenge when rendering black or nearly black subjects.

I have an artistic rule in my studio for all my students to memorize: Black isn't black, and white isn't white. Both of these tones reflect highlights and are altered by shadows. The result is a collection of contrasting tones. To understand this, squint at the photo on this page. You will see a mosaic of light areas reflecting off of the poodle's curls. This is what we want to capture.

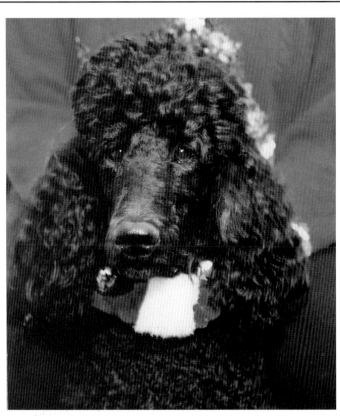

Reference Photo

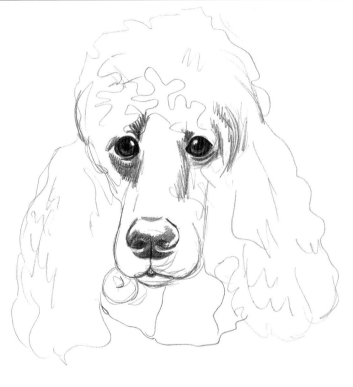

1 Remove the Grid Lines

Check the accuracy of the line drawing you created for this dog on page 21, then erase the grid lines. Here I've already begun developing the eyes, nose and a few darks that shape the contours of those areas. I left the catchlights where I saw them in the photo, because the eye direction is clear.

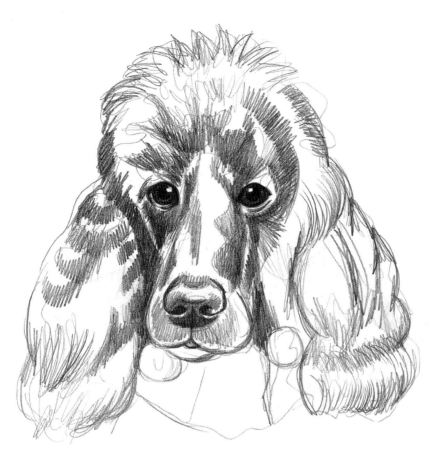

2 Pencil the Darks of the Fur

Look at the reference photo and squint your eyes to see the patterns of light and dark in the dog's black fur. Fill in the darkest areas of the fur, following the direction of the hair's growth. To create the impression of curls, apply the dark "spots" where the fur is thick. By creating the dark areas, you will automatically create the adjacent light ones.

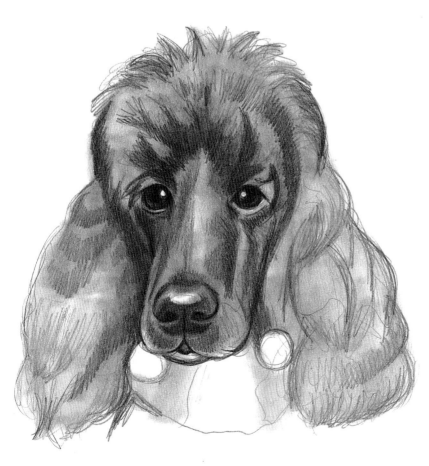

3 Blend the Entire Drawing

Blend the entire dog with a tortillion. This will remove the white of the paper and create the middle tones for depth.

4 Reapply the Dark Tones

Start reapplying the dark tones to deepen them. It is important to make the dark areas extremely black or the dog will appear flat once the drawing is finished.

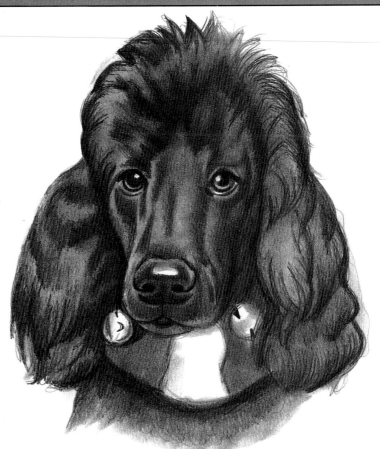

5 Lift Out the Highlights and Build Texture

Use a kneaded eraser to lift out the many highlights. Use quick strokes with both the eraser and a pencil to reproduce the look of the hair's texture. You will need to repeat this process many times to build up the curls and layers. Your drawing will look weak and unfinished if you stop too soon.

For this portrait I decided to place all of the focus on the poodle and eliminate the background. I included the holiday scarf and bells for interest, to make the portrait more creative.

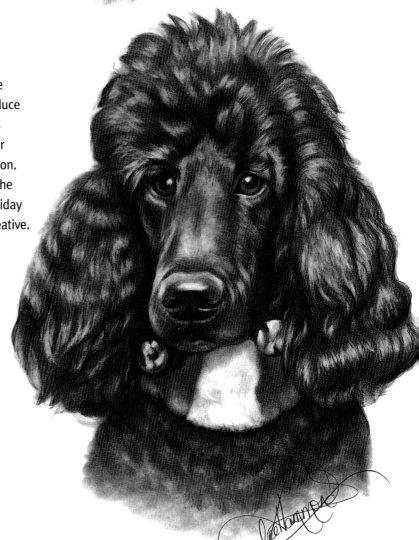

Fluffy Fur

This beautiful kitten has fluffy, light-colored fur and subtle markings. Much of the drawing will be done with a dirty tortillion to create a soft impression.

 We do not have a line drawing already made for this one, so grab a fresh sheet of drawing paper.

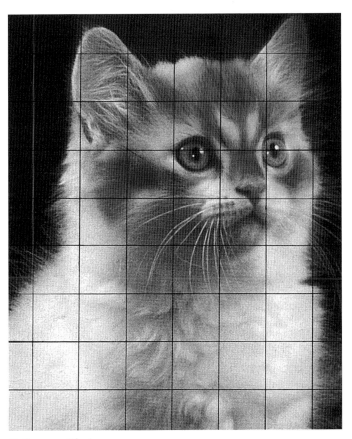

Reference Photo

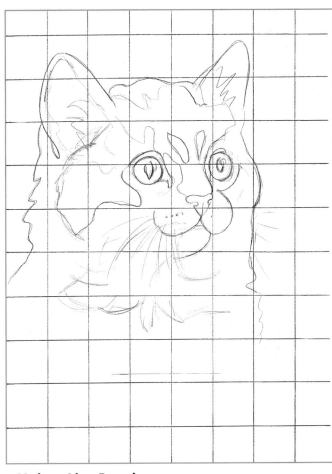

1 Make a Line Drawing
Lightly pencil on your drawing paper a grid that is seven one-inch (3cm) squares across and down. Create an accurate line drawing.

2 Develop the Eye and Nose Area

Erase the grid lines, then begin with the eyes. They look bright and sparkly and are the main focus of this portrait. Leave two catchlights in each eye to help make the eyes shine. Notice the light reflecting around the pupil and the outside edge. Add the gray markings around the eyes and nose with quick pencil strokes that follow the direction of the hair.

3 Blend the Drawing

Blend the markings of the fur with a tortillion to make them look soft. Blend the eyes to make them look shiny. Lift out the catchlights with a kneaded eraser.

4 Add Background Tone
To make the white fur of the cat stand out against the white of the paper, apply some tone to the background and blend it until smooth. This helps to create a light edge on the cat, which can be easily seen around the ears. Using background tone avoids the amateurish look of an outline, especially when drawing a white or light subject.

5 Finish the Fur and Add Details
Develop the fur until you are satisfied and then add the final details, including the whiskers. With a kneaded eraser, lift out the light fur on the chest to create the illusion of layers. The separation of the fur should be clearly illustrated, making the fur look very thick and full.

As you can see, white isn't really white. Most of this finished drawing has tone in it; very little of the white of the paper is left revealed. The heavy use of blending makes the fur look extremely soft and fluffy. The dark background really helps with the overall look of this portrait. It makes details such as the delicate whiskers and the hairs coming out from the ears show up.

5 Cats

To fully understand how to draw certain subject matter, you must have a good working knowledge of it. Drawing animals is no different. The previous chapters gave you a nice introduction to several types of domesticated animals. However, it was limited mainly to the face and fur details. To be totally proficient, you must practice drawing an animal in its entirety, including the body in different poses.

To draw cats accurately, it is important to study the anatomy of a cat and understand how its body moves.

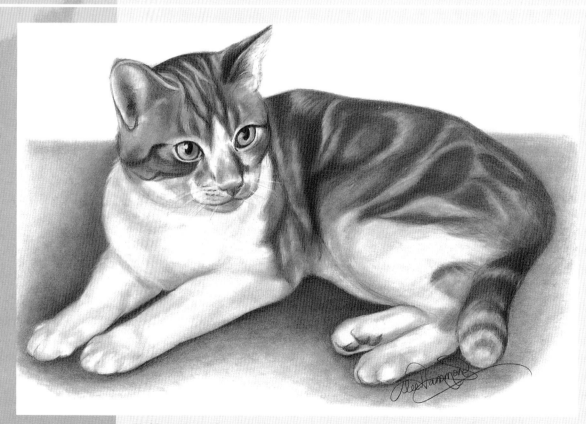

Making Himself at Home
Burnie came into my life in 2003. He had crawled into the engine of a car and was driven for fifteen miles before he was discovered. The bottoms of his paws were severely burned (hence his name, Burnie). He was in intensive care for a month and no one came to claim him, so my vet gave him to me.

This drawing captures Burnie in his favorite position: lying on someone's drawing table in my studio. I actually think he believes he owns the place!

A PORTRAIT OF BURNIE
11" × 14" (28CM × 36CM)

Seeing the Basic Shapes

Everything can be broken down into its underlying basic shapes. Some of the most common ones in animal drawing are the sphere, the egg, the cylinder and the cube.

A cat has a very round contour. These line drawings show the sphere of the head and the egg shape of the body quite clearly. Look for these underlying shapes as you draw, and your artwork will have better form.

Reference Photo

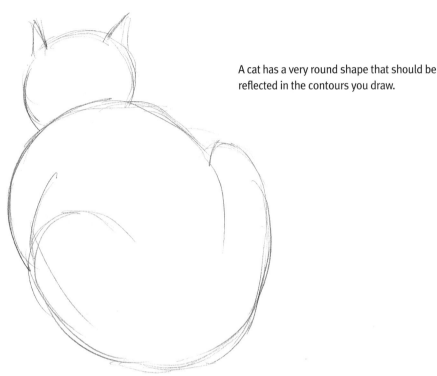

A cat has a very round shape that should be reflected in the contours you draw.

Reference Photo

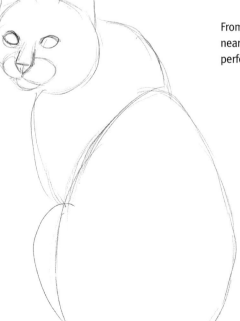

From this angle, the cat's back end resembles a nearly perfect egg, and its head is an almost perfect sphere.

Markings on Fur

One of the characteristics that makes cats so beautiful is the many different ways their fur can look. A cat's coat is like a fingerprint, where no two are exactly alike. They can have a multitude of colors and markings, ranging from solid colors and stripes to spots and swirls. The following examples show how beautifully unique different cats can look.

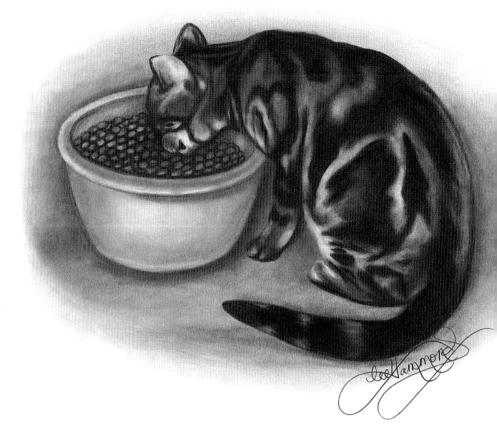

Tigerlike Markings

This is a Bengal tiger cat, a breed that is known for its very large size and gorgeous markings. While this is more of a candid pose as opposed to a planned portrait, it shows off well the cat's exquisite markings. To create unusual markings such as this, it is important to look at the markings as a puzzle. Just by filling in the dark areas, you will create the light ones.

A Splotchy Coat

This portrait of a Persian shows off this cat's fur, whose big splotches of distinct color are typical for a calico. If you look closely, you can see how I used pencil strokes to create the fullness of the coat. I also used a kneaded eraser to lift out the light fur, making it appear to overlap the dark areas.

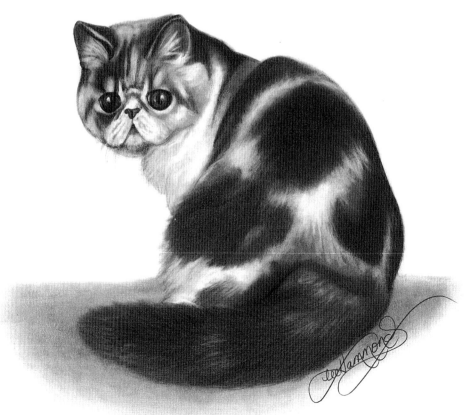

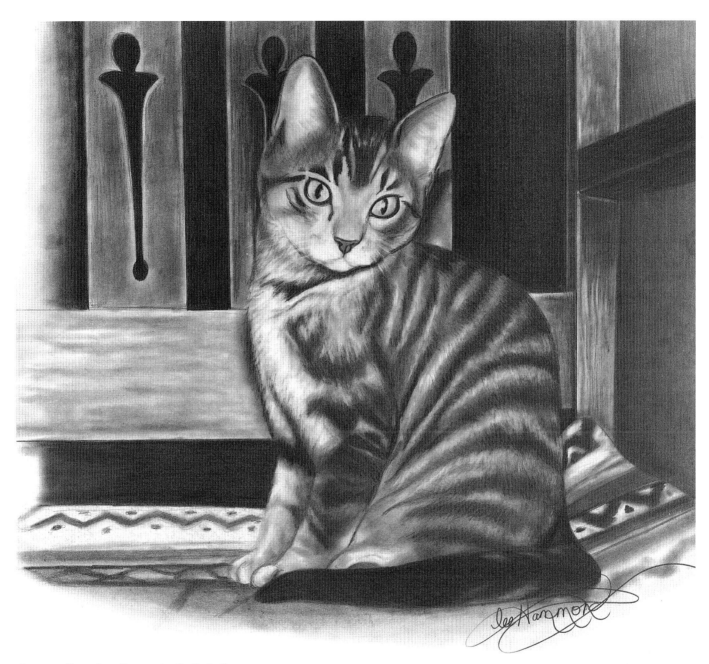

Surroundings Can Support a Cat's Pattern

This cat remains the focus of the drawing even though it's surrounded by scenery. The dark, relatively simple background gives just enough information to establish a home setting while still allowing the cat to be the main focus. Showing the small corner of patterned blanket creates additional visual interest without drawing too much attention away from the stunning stripes of the cat. The combination of shapes, tones and textures makes this a great composition with a lot of artistic impact.

WORK FROM GOOD PHOTOS

Often, a customer will provide me with photos that are not adequate for drawing. They are too small, out of focus or both. People who do not draw may not realize that a good photo is essential to creating good art. Do not hesitate to turn down a job due to a lack of good photography. Ask for better pictures or offer to take them yourself. Your artwork is only as good as the photos you work from, so always require the best!

Striped Cat

This is a typical pose for a house cat. The upward angle creates an interesting view that shows off the animal's beautiful eyes and spectacular stripes.

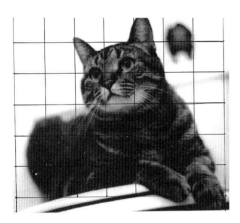

Reference Photo

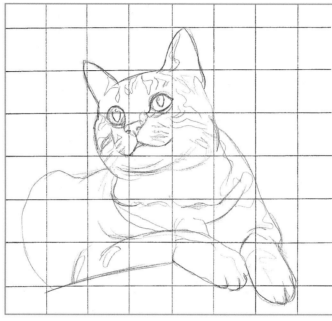

1 Make a Line Drawing

Lightly draw on your drawing paper a grid of one-inch (3cm) squares to correspond with the graphed photo. Then follow each box to create an accurate line drawing.

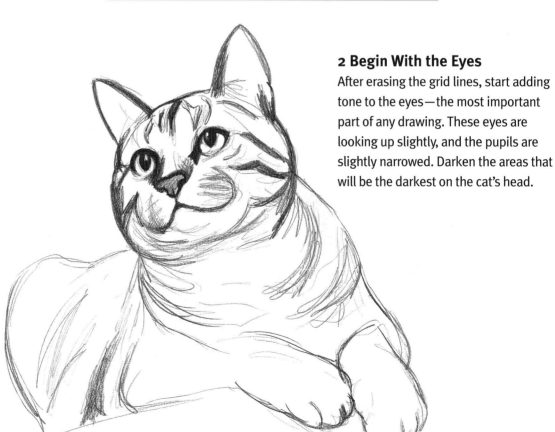

2 Begin With the Eyes

After erasing the grid lines, start adding tone to the eyes—the most important part of any drawing. These eyes are looking up slightly, and the pupils are slightly narrowed. Darken the areas that will be the darkest on the cat's head.

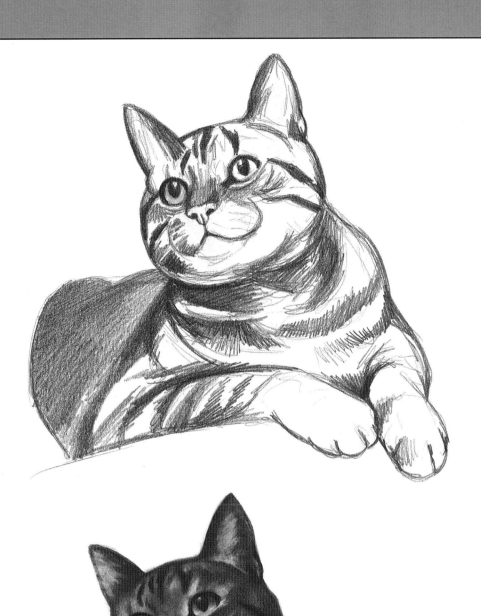

3 Develop the Fur Patterns

Start to fill in the dark areas that make up the markings of the fur. Notice how the backside of the cat is dark and blurred to create depth.

4 Blend the Tones and Reapply Pencil Lines

Use a tortillion to blend the tones, creating a smooth, soft appearance. Reapply the pencil lines to deepen the markings of the fur, and then use a kneaded eraser to lift out the light fur and the whiskers. Add a shadow below the cat to create the illusion of solid ground. The eyes' catchlights are tiny but convincingly create form.

Drawing Kittens

Kittens are not simply miniature versions of their elders. Their faces are small, but their ears look disproportionately large. Unlike a puppy's paws, kitten feet are very small and delicate. Kittens also have round tummies and heads and tend to look frisky even when at rest.

To draw these examples, you could place an acetate grid over them to capture their shapes puzzle-piece style, or you could try freehanding them. Refer to the previous chapters on how to draw fur and see if you can re-create these little guys. Pay particular attention to the length of the fur. One kitten has short hair, while the others have longer fur. The length of your pencil strokes should match the length of the hair. Be sure to study the facial features as well. Each of these kittens has a different bone structure unique to its individual breed.

Longhaired Angora kittens have wispy fur and round faces.

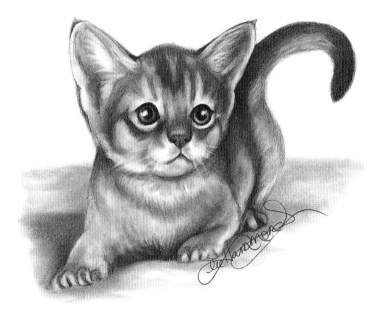
Abyssinian kittens have small, angular faces and very short fur.

A Persian kitten has a very flat face and full, thick fur.

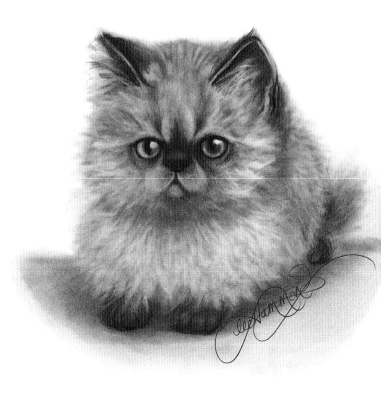

AVOID GENERIC DRAWINGS

Capturing the major and minor differences among the varying breeds is crucial when drawing realistically. It keeps your work from appearing "stylized," with everything looking generic and somewhat similar. That is what caricature drawing is designed for.

Domestic Shorthaired Kitten

This is a wonderful example of how some well-composed photos truly lend themselves to creating art. A student of mine brought this photo to class, and I immediately had to borrow it for this book. I love combining children and pets for drawings. Even though you cannot see the entire child in this photo, you can tell by the shape and size of the hand that it belongs to a youngster. It is so cute to see a young child cradling a baby kitten. It is always nice to evoke a mood and create emotion with your artwork.

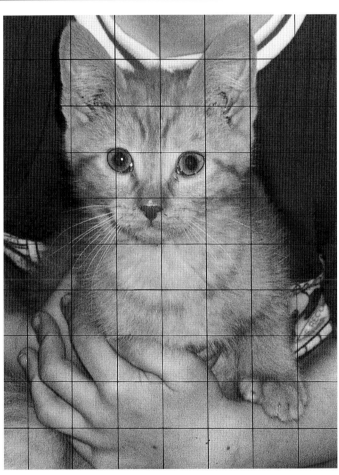

Reference Photo

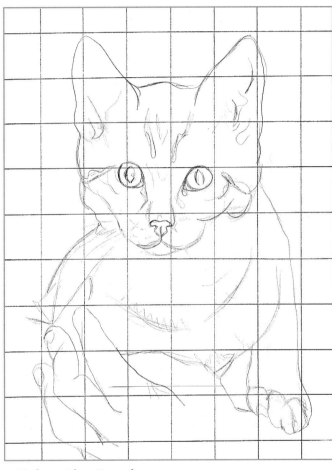

1 Make a Line Drawing

Lightly draw on your drawing paper a grid of one-inch (3cm) squares: eight squares across, ten squares down. Draw what you see inside each box to create an accurate line drawing of the photo. Notice how huge the kitten's ears are; this is crucial to conveying its young age.

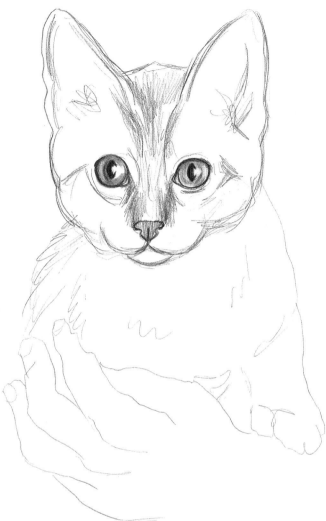

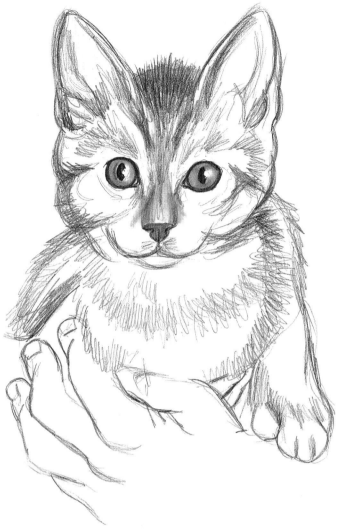

2 Capture the Eyes

When you are satisfied with the accuracy of your line drawing, carefully remove the grid lines. Begin with the eyes. The kitten is giving you full eye contact, and this is where all the emotion is in the drawing. To capture its wide-eyed look, make the pupils more oval-like than slitlike. Start creating the contours of the nose and the area between the ears.

3 Draw the Fur Markings

Continue with the darkest areas of the cat, and fill in the markings of the fur on the face and body. Add quick pencil strokes to the body to create the little stripes of the fur. Add dark tones to the paw. Darken the contour lines of the hand.

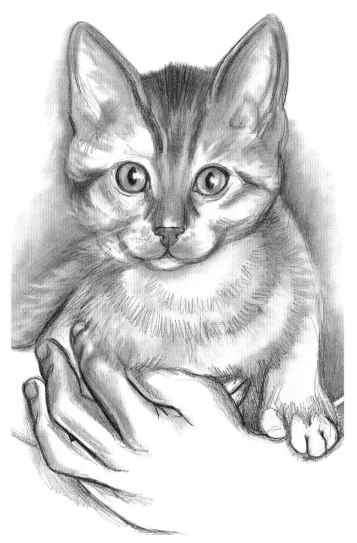

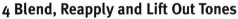

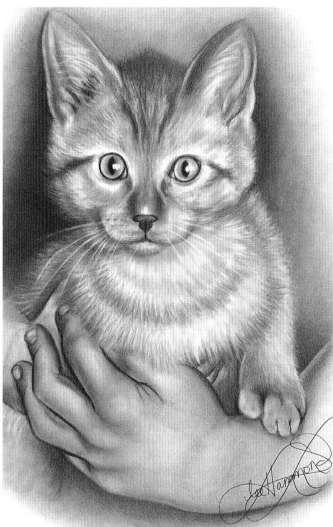

4 Blend, Reapply and Lift Out Tones

Blend the tones with a tortillion to remove most of the white of the paper. Reapply the dark pencil lines with quick strokes to replicate the fur's soft texture. Then lift out the light fur with a kneaded eraser to make it look fluffy. To make the light edges of the cat show up, add some tone to the background. Blend it and let it fade as it goes toward the edges. Use your tortillion to make the transition gradual and smooth.

Refer to the sphere on page 14 when applying the tones to the hand and the arm. The fingers and the arm are continuous, rounded forms in which all five elements of shading are present. If you look closely, you can see reflected light along each of the fingers and along the edges of the arm.

5 Build Layers

Keep pencilling, blending and lifting out tone for as many layers as it takes to resemble what you see here. Then complete the arm and hand. Blend the tones to replicate the smoothness of the skin. To show the reflected light along the edges of the arm, apply some tone below it, as we did around the cat. Blend the arm with a tortillion and let it fade out at the edges.

Portraying Cats in Action

Showing the actions and behaviors of your pet can reveal in a drawing what you love about its personality. Your camera should always be available to capture the moment. You never know when an artistic opportunity will come your way.

Draw a Kitten at Play
This little kitten is very busy, having a lot of fun with the ball of yarn. Always have your camera ready for cute moments such as this.

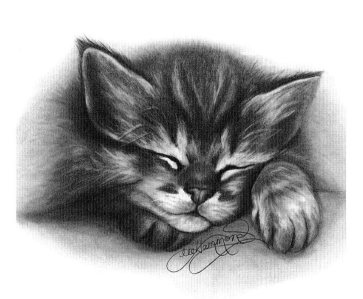

Take Advantage of Cat Naps
Your cat's naptime is the perfect time to capture some adorable inactive poses with your camera. Even a simple drawing like this can tell a story. This sleeping kitten's peaceful expression tells you everything you need to know; you won't have to elaborate on the surroundings.

Draw Various Facial Expressions
Sometimes it is fun to deviate from the typical and traditional poses and draw an expression like this wide-open yawn.

Domestic Longhaired Cat

This kitty seems perfectly content to do nothing at all—at least for the moment! An oval-shaped background lends to the formal look of this restful portrait.

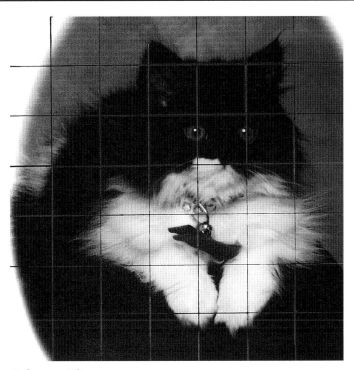

Reference Photo

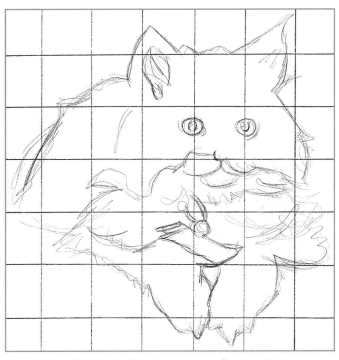

1 Make a Line Drawing

Lightly draw on your drawing paper a grid of one-inch (3cm) squares. Create an accurate line drawing based on the graphed photo.

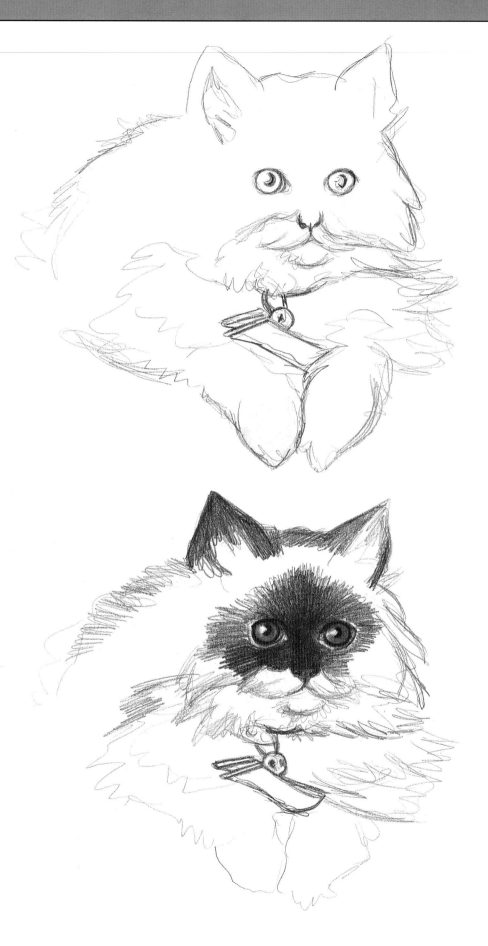

2 Erase the Grid Lines

Carefully remove your grid lines with a kneaded eraser. Clean up the lines of the eyes and nose for accuracy.

3 Begin the Face and Ears

Start by rendering the eyes. Place the catchlights half in the pupil and half in the iris. Blend the irises to make them look smooth and shiny.

Begin pencilling in the dark fur of the face and ears, making your pencil lines follow the direction of the hair. Fill in these areas with pencil lines until they are very dark.

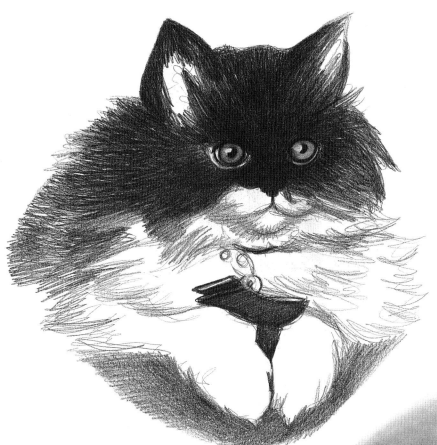

4 Develop the Fur

Continue the drawing by adding more pencil lines in all of the dark areas. Use quick strokes to make the pencil lines taper at the ends; this will make the fur look more natural. Define the white fur of the mouth and body with carefully placed lines, indicating shadows, that follow the direction of the hair.

Add the shadow under the feet to help define their shape. Define the paws further by filling in the dark shadow between them and also the bow on the cat's collar. White objects always need tone around them to make them show up.

5 Finish the Fur and Add a Background

Finishing will require a lot of blending with a tortillion. Blend the shadow areas of the white fur. Build up and blend the black fur to make it appear soft and fluffy. Use a kneaded eraser shaped into a point to quickly lift out the light fur that overlaps some of the darker areas and to create a few light whiskers.

Create the oval background by adding tone and blending smoothly. Ground the cat by reserving the darkest tones for the shadow below the cat.

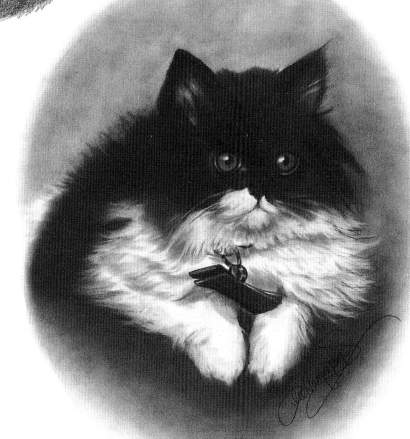

6 Dogs

Dogs hold a very special place in our hearts. Unlike cats, which are very independent and aloof, a dog is totally devoted to its owner. My cats are wonderful, but everything is on their terms. Sometimes I feel as if they own the place and merely tolerate me! My dogs, however, treat me as if I were the queen of the world and act as though I've been gone forever if I leave the room for only a moment.

The expressive nature of man's best friend makes him an ideal subject for drawing. Just as with cats, great variety exists among the breeds, but the techniques for drawing them remain the same.

A Formal-but-Telling Pose

You first saw Misty on page 22. Unlike that somewhat candid pose, this one is more formal. She is like a big teddy bear, and I wanted to capture that quality in a simple head-and-shoulders drawing.

Look closely and you can see the numerous pencil layers it took to build up the fluffiness of her fur. Since she is white in many areas, I opted for a shaded background. I then lifted out the white hairs from the background, creating a furry impression. I blended the background tone, fading it into an oval shape. When I frame this piece, I will place an oval mat around it for a classy look.

MISTY
14" × 11" (36CM × 28CM)

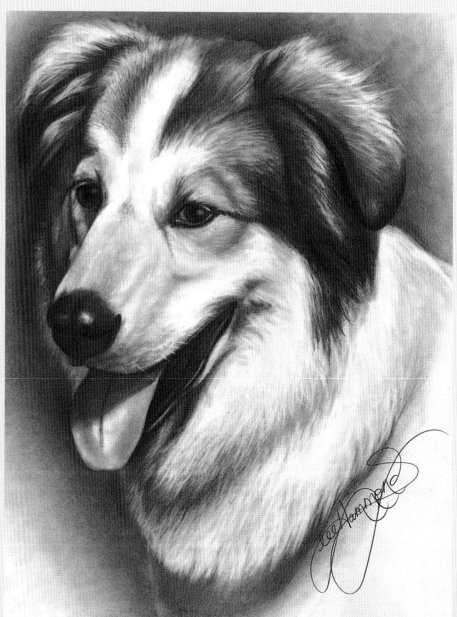

Seeing the Basic Shapes

We learned in the previous chapter how to see the basic shapes in the contours of a cat. Dogs, however, are more muscular than cats, and that makes them generally boxier in shape. A cat has a sleek appearance that makes it seem as one continuous form; a dog is much more angular.

Compared to the form of a cat, a dog is much more angular.

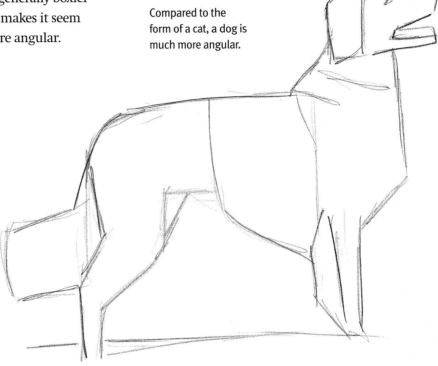

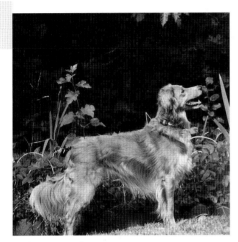

Reference Photo

Reference Photo

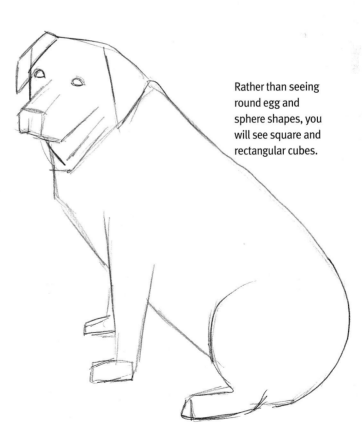

Rather than seeing round egg and sphere shapes, you will see square and rectangular cubes.

Labrador Retriever

I like this photo of Kimber, my son's yellow Lab, because of the lighting. Having one side of the face light and the other side dark makes for a dramatic drawing.

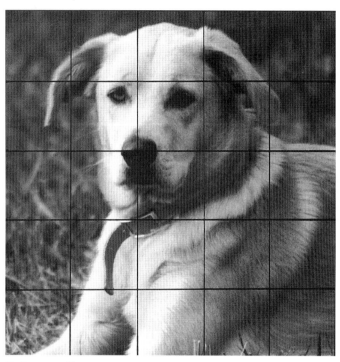

Reference Photo

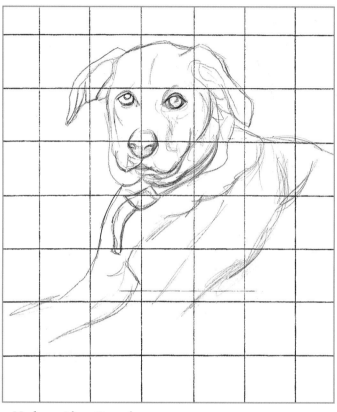

1 Make a Line Drawing

Using the graphed photo as a guide, create an accurate line drawing.

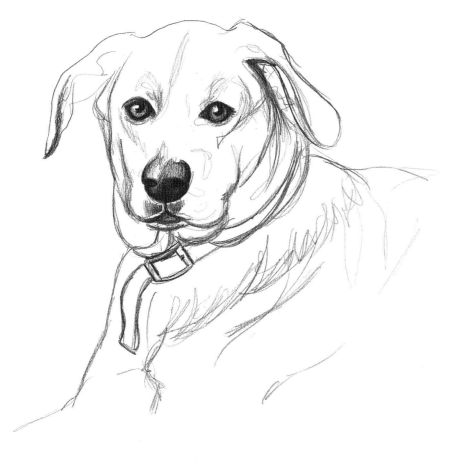

2 Render the Facial Features

Erase the grid lines, then start rendering the eyes, nose and mouth. This allows you to capture the personality first, and it establishes the darkest tones of the drawing.

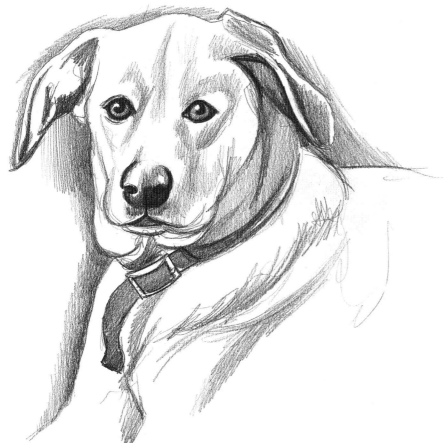

3 Develop the Body, Collar and Background

Add tones to the shaded side of the face, looking for the anatomy and the form. The shadows reveal the contours of the dog's face. Fill in the collar.

Create the dog's edges by pencilling a shadow around the animal. Because this is a light-colored dog, careful shading is crucial to bring her off the paper. Harsh outlines would make the drawing look like a cartoon.

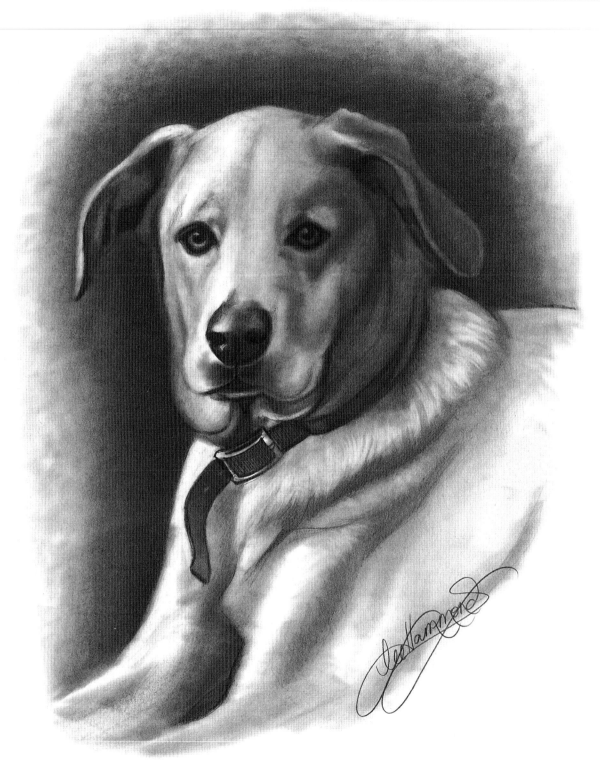

4 Build and Blend the Tones

Repeatedly add tone and blend with a tortillion to make the drawing come alive. Lift the light fur with a kneaded eraser to create texture and the fluffy hair around the neck. Use the same eraser to lift out the highlights and areas of reflected light. Lifting out the lights always looks more realistic than just drawing around them. Make the background extremely dark to help clearly define the dog's edges and to heighten the drama of the portrait.

Bulldog

This English bulldog was a great subject to draw—the creases and folds make it a much more complicated subject. Each fold must be seen as a tublar structure, and the five elements must be addressed. If you look closely, you can see shadow edges and reflected light repeated in many areas.

The extreme lighting and dark background add to the dramatic effect. The darkness makes the light areas leap off the paper.

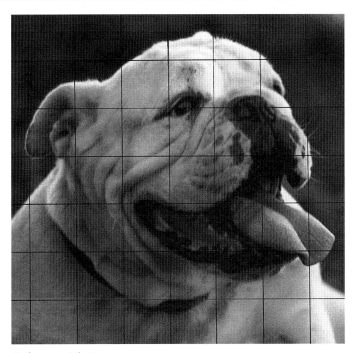

Reference Photo

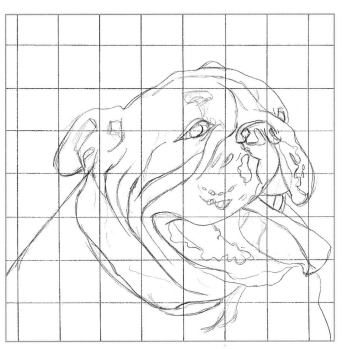

1 Make a Line Drawing

Be as accurate as you can, especially when drawing the dog's large, expressive mouth.

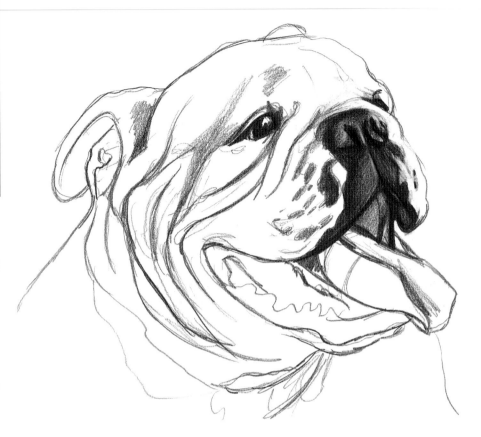

2 Draw the Eyes and Nose

Double-check all of your shapes before erasing the grid lines. Start with drawing the eyes. Because of the turn of the dog's head, you will see more of the eye closest to you, and it will appear larger. The other eye is almost completely hidden by the face. Everything on the dog should be drawn with this angle in mind.

Fill in the dark tones of the nose and surrounding spots. Blend the tones of the nose, and then lift out the highlights with a kneaded eraser.

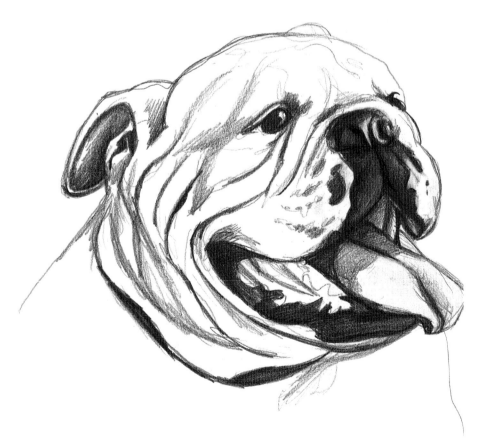

3 Work on the Mouth

Work down to the mouth area, filling in the darkest areas first. The lower lip is extremely dark, and so is the area under the tongue. Fill in the dark tone of the collar. Resist the temptation to draw it as a perfect ring, since a skin fold overlaps it.

Study the photo carefully to see all of the small details. The tongue is divided right down the middle. It is darker on the far side, and the muzzle casts a shadow across it.

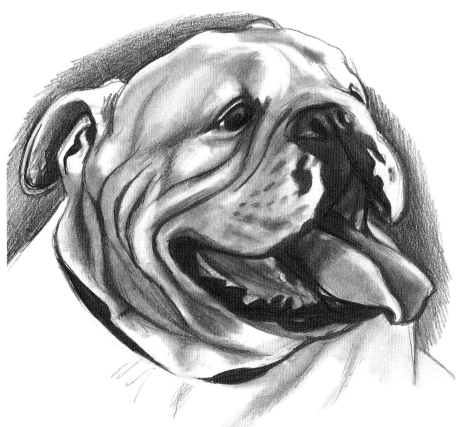

4 Develop the Wrinkles and Background

Pencil some background tone around the dog to help describe his edges. Then start developing the wrinkles and creases of his face. Remember my theory that white isn't white. This white dog is reflecting a lot of the shadows and colors of his surroundings. Use a dirty tortillion to smoothly draw these areas of tone on the face.

Look for all of the edges of reflected light present around the upper lip and the nostrils and along the edges of the creases in his face. Lift out these areas with a kneaded eraser.

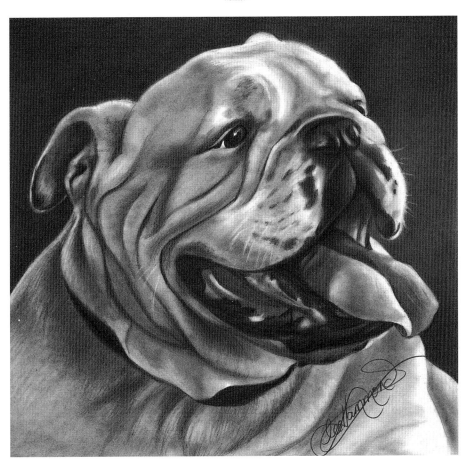

5 Finish Building Tones

Create a border box around the dog and finish filling in the dark background tones. Keep them very even and smooth by blending them with a tortillion. Keep adding and blending tone and lifting out light areas until you are satisfied with the dog. Lift out the whiskers with a kneaded eraser.

Cocker Spaniel

This is an example of a foreshortened subject. The back end of the dog is partially hidden by the front, and the dog's body appears to get smaller as it recedes in space. Recreating this dog as we *see* it is key to making a realistic drawing with depth.

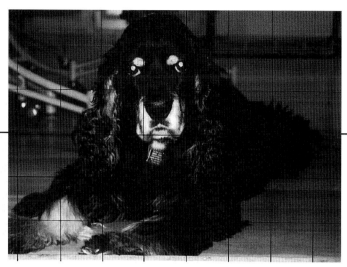

Reference Photo

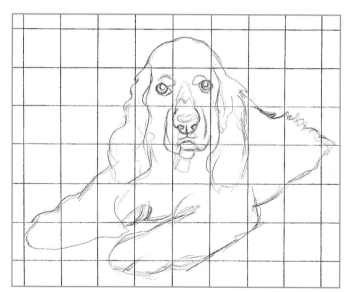

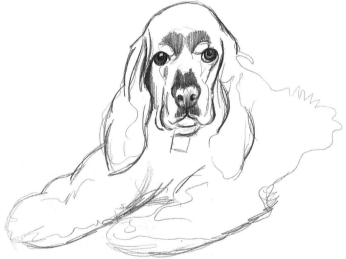

1 Make a Line Drawing

Use the graphed photo to create an accurate line drawing. Concentrate on the dog's overall shape rather than the small details of the fur, especially since this animal is so dark.

2 Begin Developing the Face

Carefully remove your grid lines. Start rendering the eyes, nose and mouth. Even though this dog is extremely dark, the highlights create distinct patterns and shapes. Look for these patterns when applying tones.

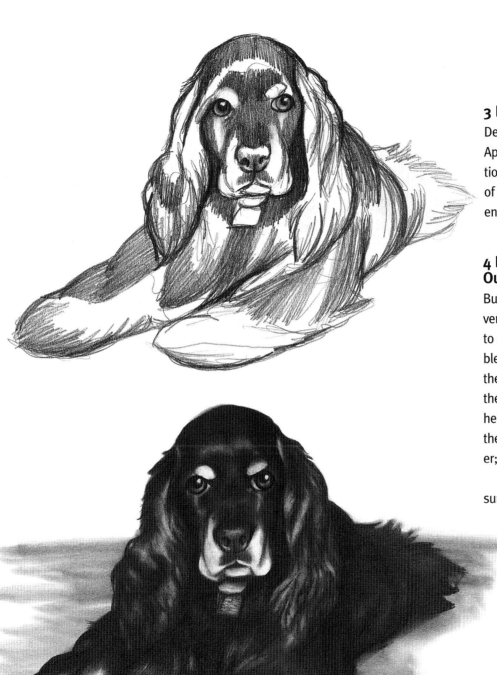

3 Build Up the Darks

Develop the depth of tone on the fur. Apply the pencil lines in the same direction that the fur is growing. The patterns of light and dark should be very apparent at this stage.

4 Deepen, Blend and Lift Out Tone

Build up the dark areas until they are a very deep black. Then blend the tones to make them very smooth. Lightly blend the lightest areas, too, to remove the harsh white of the paper. Reapply the pencil lines for some texture and to help create the waves of the fur. Lift out the fur's highlights with a kneaded eraser; think of it as "drawing in" the light.

Ground the subject by indicating a surface of subtle, blended tone.

Drawing Puppies

Like kittens, or any baby animals, puppies are incredibly cute. They have about them such a look of innocence that is hard to resist. When drawing puppies, remember that they have many characteristics that showcase their youth. Their heads are very rounded since their bone structure has not yet developed and become angular. Their feet and knees will appear huge, especially in large breeds. Also, their tummies are very round and full, much like human infants.

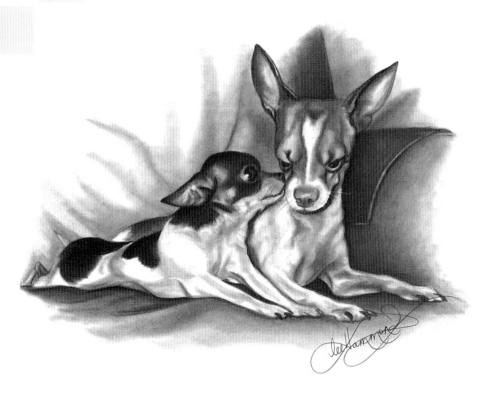

Puppy Love
Chihuahuas have such intense personalities, and this really comes across in this picture. The older dog looks so entirely annoyed with the little one, while the puppy looks up at him with such adoration.

A Contented Pup
This is my son's yellow Labrador retriever mix, Kimber. Her round forehead and bulging tummy indicate that she is just a baby here. She has always been such a quiet, calm dog, and this aspect of her personality comes through in this portrait.

She is featured earlier in this book as an adult dog. Compare and you can see how much her bone structure changed.

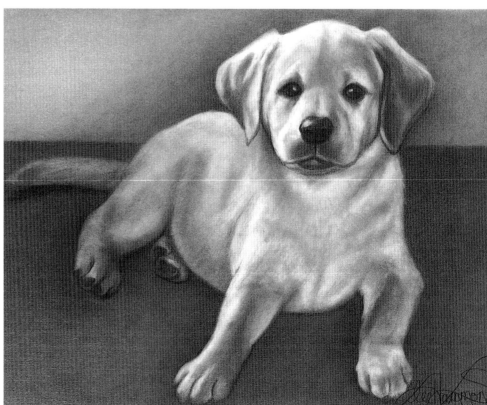

Boxer Puppy

I fell in love with this photo as soon as I laid eyes on it. This little boxer pup seems so clueless and helpless. His form is obviously very square, and his large puppy legs are characteristically disproportionate to the rest of his small body. His fur is very short and contains extreme contrasts of light and dark.

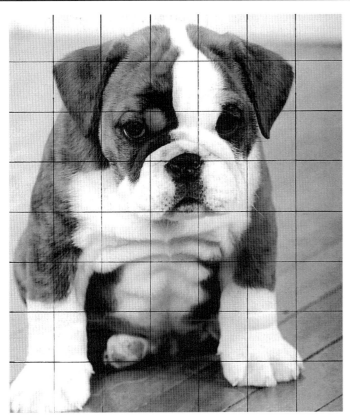

Reference Photo

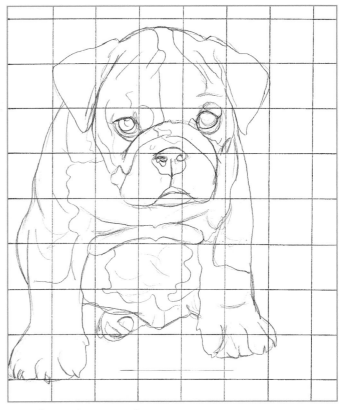

1 Make a Line Drawing
Draw the puppy's shapes and general fur pattern as accurately as you can.

2 Start With the Eyes

Erase the grid lines, then begin drawing the eyes. In the photo, the eyes are very dark. In the drawing, accent them with brighter catchlights for more life and sparkle. This doesn't change the expression but enhances it.

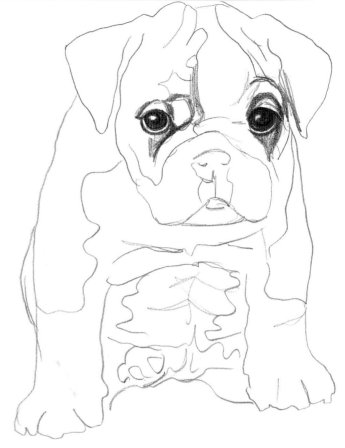

3 Move On to the Face and Ears

Render the darkest areas of the face and ears, adding the deepest tones to the nose. Look for the areas of reflected light around the nostrils and lift them out with a kneaded eraser.

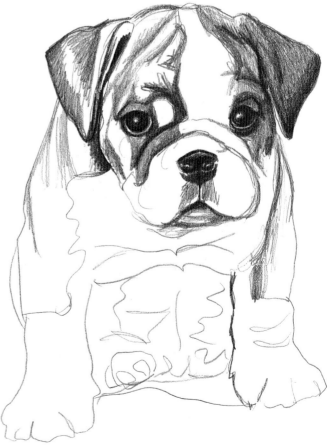

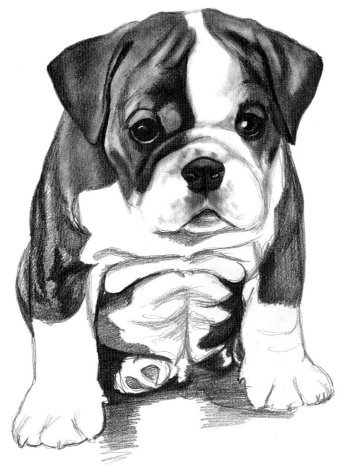

4 Add Tone to the Body and Blend

Blend the tones on the head to make them smooth, and then lift out the light areas with a kneaded eraser. You can see these areas along the edges of the ears and around the creases of the face. Add tone to the legs using the same approach used for the face. Apply some very dark tone to the inner edges of the front legs and to the shadowed back legs underneath his body.

Use a dirty tortillion to add shading on the lightest areas of the puppy. These tones are very subtle but do a lot to create form. Rough in the shadows beneath the dog.

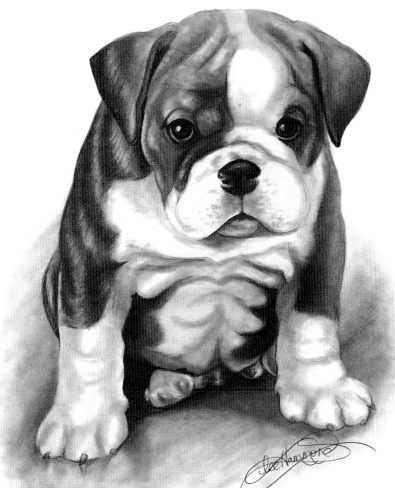

5 Complete the Blending and Shadow

Finish blending both the dark and light areas of the body.

Blend and complete the reflective shadow below the puppy, which is a silhouetted mirror image on the shiny floor. This dark tone describes the white parts of the legs without making them look outlined.

Get Creative With Candid Poses

Candid poses can speak volumes about the personality of your pet. They can also keep your artwork from becoming dull and predictable. The following examples will show you how various poses can inspire cute, creative artwork.

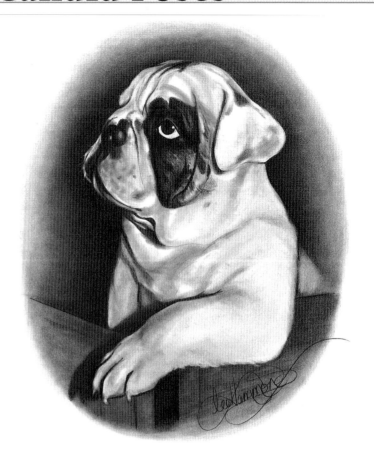

Humanlike Poses
Sometimes animals can act almost human. To me, this pug looks like a distinguished old man. The lighting in the reference photo provided wonderful extreme contrasts that make the drawing look even more dramatic. All eyes are definitely on this dog.

Enthusiastic Moments
This little guy is brimming with enthusiasm. You can imagine that his owner has just come home after a long day's work and pulled out the walking leash or a treat. This mixed breed has the wiriest hair I have ever seen on a dog. He looks like a walking scouring pad. I really worked the pencil and kneaded eraser to create his coarse texture.

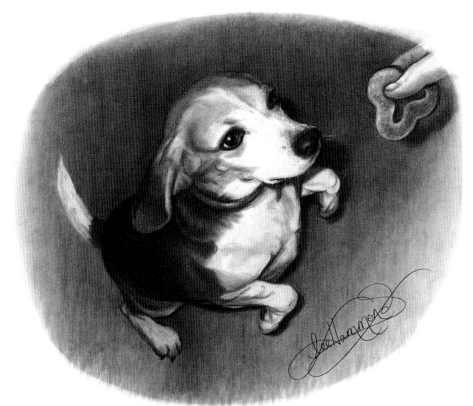

Viewer Involvement

I like this pose because of the perspective. It's as though we, the viewers, are about to reward the beagle for a job well done. A pose such as this can make your viewers feel like they are part of the scene.

The perspective of looking down on the dog from above gives this drawing depth. The head looks larger than the rest of the dog because it is closer to us. The vertical lines in the shading behind the dog give the illusion of a floor beneath him. By including the hand of the owner, I was able to add a size relationship and further the feeling of distance.

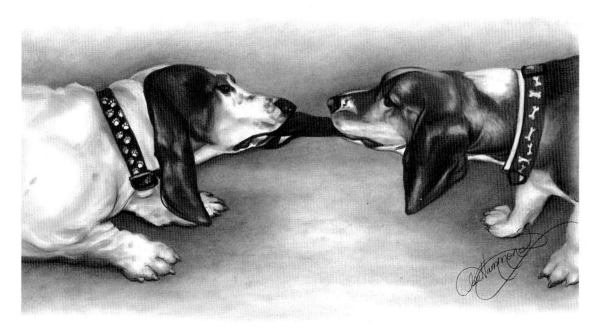

Playtime

Dogs love to play, and their antics make for cute photos to draw from. These two buddies playing tug-o-war was a nice switch from the standard head-and-shoulders portrait. My friend June rescues basset hounds, and this drawing will make a nice piece for her to hang in her home. It displays the fun-loving nature and playfulness of her "babies."

Basset Hound

Sometimes the personality of an animal is best captured with overall body language rather than just a facial expression. This pose speaks volumes about the character of this basset hound. Could she be any more relaxed?

Reference Photo

1 Make a Line Drawing

If you would like to draw this image larger, make the squares on your drawing paper one and a half or two inches (4cm or 5cm) instead of using one-inch (3cm) squares.

2 Draw the Ears and Facial Features

After erasing the grid lines, add the darkest tones to the head and ears. Her right eye is squeezed almost shut as that side rests on the arm of the chair. The mouth droops on that side as well and consequently looks larger than her left side. Maintain the droopiness of the ears, which is key to conveying the dog's relaxed state.

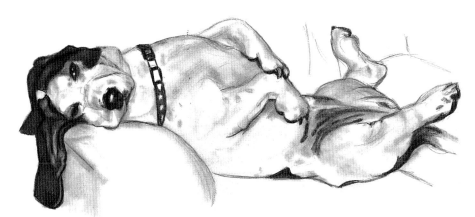

3 Work on the Body

Create the spotted patterns on the face, and use a dirty tortillion to render the subtle shading. Blend the ears, nose and eyes, and lift out the reflected light and highlights with a kneaded eraser.

Move down the body to the belly and legs, adding spots and shading with the same tortillion. Fill in the dark part of the tail, and darken the dog's collar.

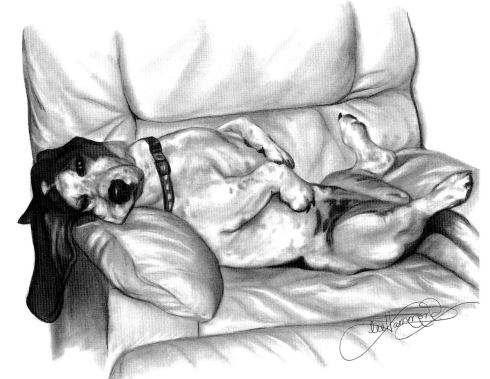

4 Develop the Chair

The white chair is made of leather, so its surface is extremely smooth. A dirty tortillion is excellent for creating textures like this. Complete the chair's shading and add a few blended pencil lines for details such as the creases.

7 Rabbits & Rodents

While dogs and cats are surely the most common house pets, many people enjoy other furry creatures from, or closely related to, the rodent family. Rabbits, mice, guinea pigs and other small animals make pleasant pets and spectacular drawing subjects.

A Picture-Perfect Pairing

This is a portrait of my friend's daughter with her little bunny. I love combining children with their pets for a portrait. Children get such joy from animals, and that comes through in this drawing.

MICALLA ALEXIS RETTINGER WITH HER BUNNY, JAZZY
14" × 11" (36CM × 28CM)

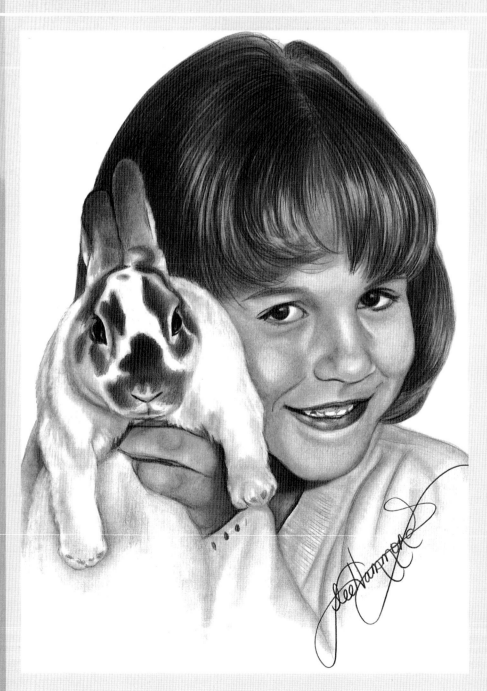

Seeing the Basic Shapes

The most common basic shapes that are seen when drawing rodents and rodentlike animals such as rabbits are that of the sphere and the egg. Rodents have very round body shapes, which make the overall shape very curvy and smooth.

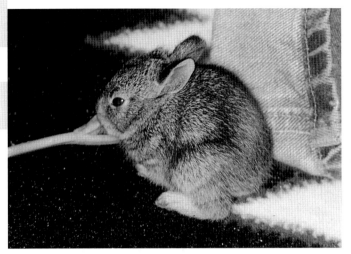

Reference Photo

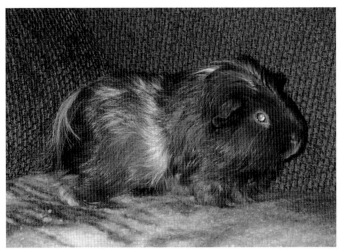

Reference Photo

A guinea pig is somewhat tubular in shape. The head and rear are very egg shaped.

The egg shape is very evident in this baby bunny.

Rabbits and Guinea Pigs

Guinea pigs and rabbits share many of the same characteristics. They both have very round, egg-shaped bodies. However, the guinea pig has a thicker neck and is closer to the ground. Let's look at a few other similarities and differences.

Guinea Pig Characteristics

Guinea pigs are fairly simple in their overall contours. My kids laugh at me when I call them "furry eggplants." The neck is not clearly defined, making the creature appear as one continuous, egglike shape. Its relatively small, dark eyes, which appear to be on the sides of the head, result in a somewhat blank stare.

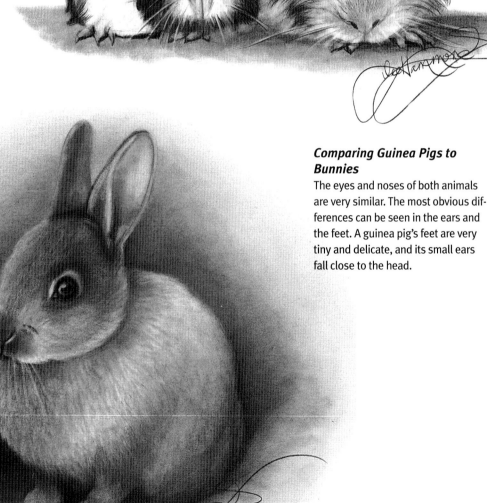

Comparing Guinea Pigs to Bunnies

The eyes and noses of both animals are very similar. The most obvious differences can be seen in the ears and the feet. A guinea pig's feet are very tiny and delicate, and its small ears fall close to the head.

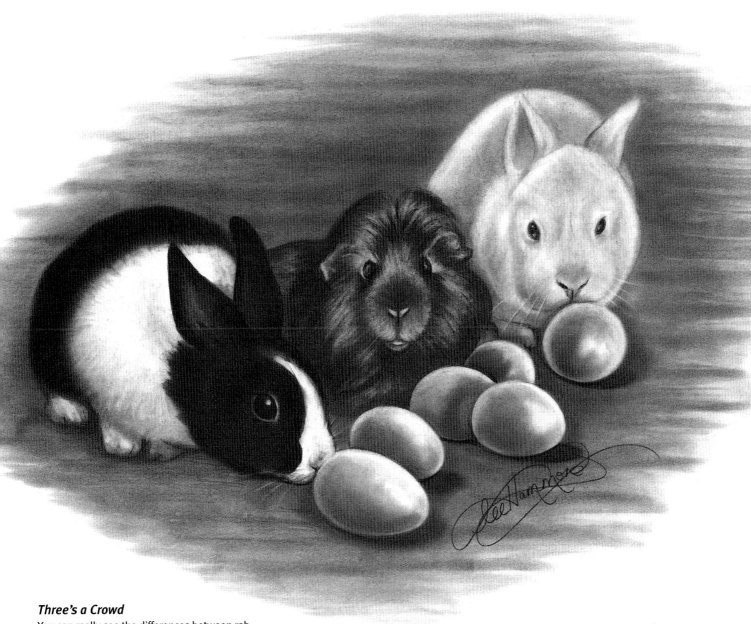

Three's a Crowd
You can really see the differences between rabbits and guinea pigs in this illustration. The little guy in the middle looks a little out of place in the scene!

Lop-Eared Rabbit

This bunny's pose creates a very simple egg shape that is easy to draw. Try it!

1 Make a Line Drawing

Make a grid on your drawing paper and re-create the line drawing you see here.

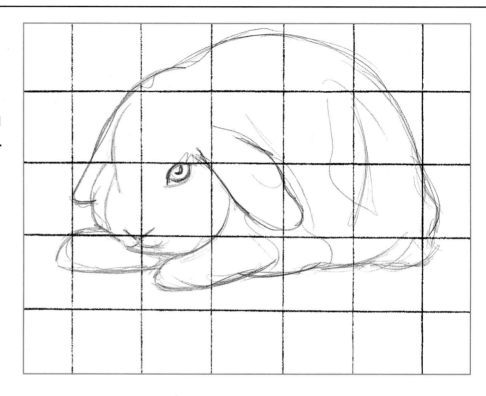

2 Erase the Grid Lines

Carefully remove the grid lines from your graphed drawing.

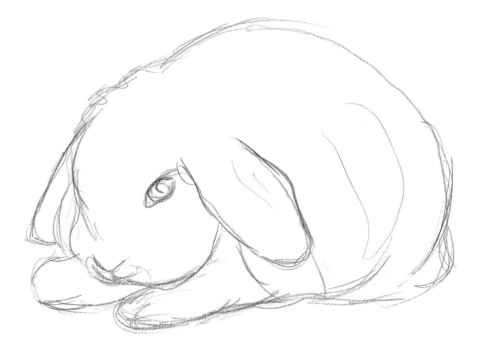

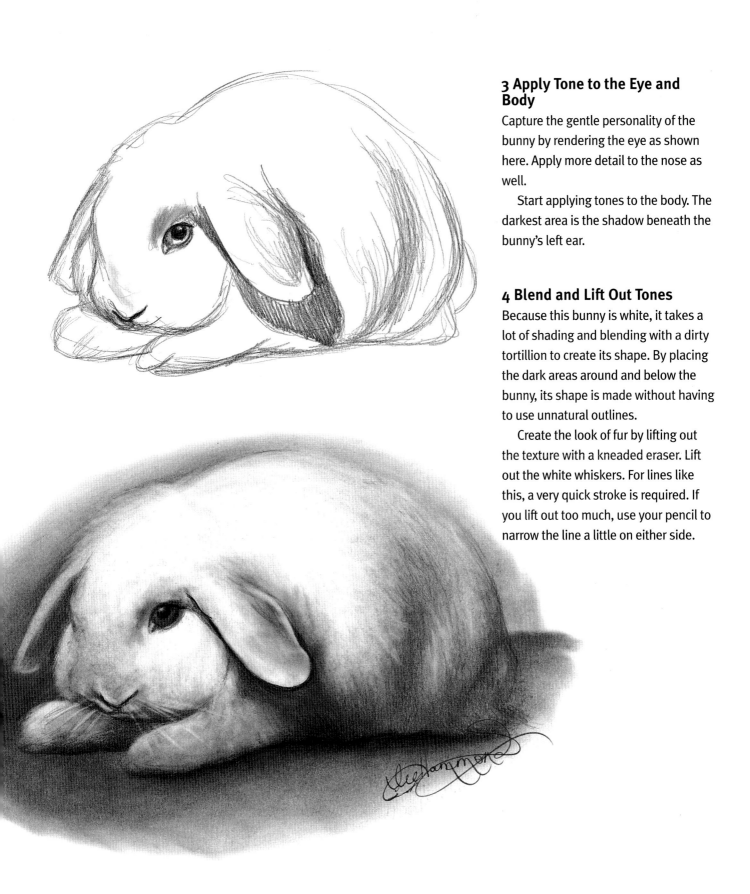

3 Apply Tone to the Eye and Body

Capture the gentle personality of the bunny by rendering the eye as shown here. Apply more detail to the nose as well.

Start applying tones to the body. The darkest area is the shadow beneath the bunny's left ear.

4 Blend and Lift Out Tones

Because this bunny is white, it takes a lot of shading and blending with a dirty tortillion to create its shape. By placing the dark areas around and below the bunny, its shape is made without having to use unnatural outlines.

Create the look of fur by lifting out the texture with a kneaded eraser. Lift out the white whiskers. For lines like this, a very quick stroke is required. If you lift out too much, use your pencil to narrow the line a little on either side.

Guinea Pig

Let's make a drawing of my "grandpig," G.P.—my grand-children's guinea pig. This simple pose is rather comical. The baby bottle in the distance gives the image a funny flair, lending an air of innocence and a babylike quality to the pet.

Reference Photo

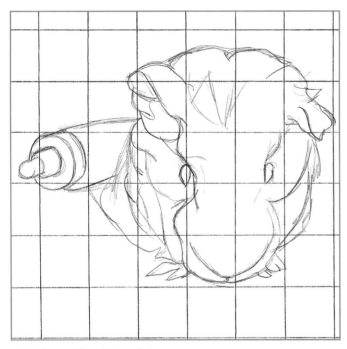

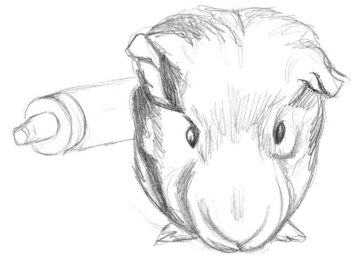

1 Make a Line Drawing

This is a fairly easy drawing to do, since there aren't many small details to capture.

2 Fill In the Eyes and Darkest Areas

Be sure your line drawing is accurate before you erase your grid lines. Begin filling in the guinea pig's eyes. From this angle, they look somewhat oval in shape; the entire eye cannot be seen. Start adding tone to the darkest areas of the pig.

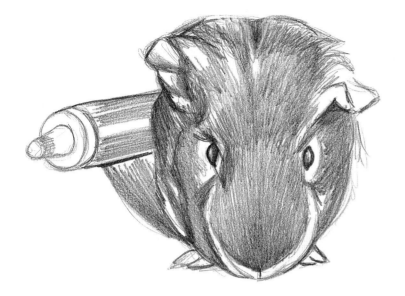

3 Create the Texture of the Fur

Add tone to the rest of the face and body, following the direction of hair growth. Use small, short strokes to create the texture of the fur. Add tone to the bottle, too.

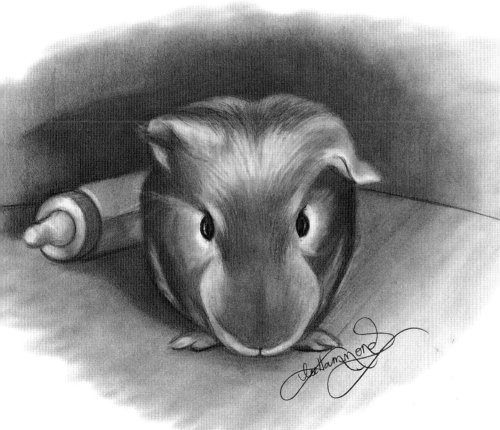

4 Build Up the Tones and Lift Out the Lights

Blend all the tones with your tortillion. Reapply the small pencil marks to make the texture of the fur more noticeable. With a kneaded eraser, lift out areas of reflected light and highlights on the top of the head and around the ears, eyes and mouth area. Do this to the bottle, too. Darken the eyes and add the feet.

Add the background with blended pencil tones. It is darkest in the guinea pig's shadow. The dark area above the guinea pig helps to define the top of the head.

A Cuddly Couple

Once again, the combination of a child and a pet creates an adorable drawing. This is my grandson, Gavyn, holding G.P. You can see the joy in Gavyn's eyes as he cuddles his pet. All of the kids in my family love pets. Flip through your own family photo album and you will surely find many opportunities like this to spur your artistic creativity.

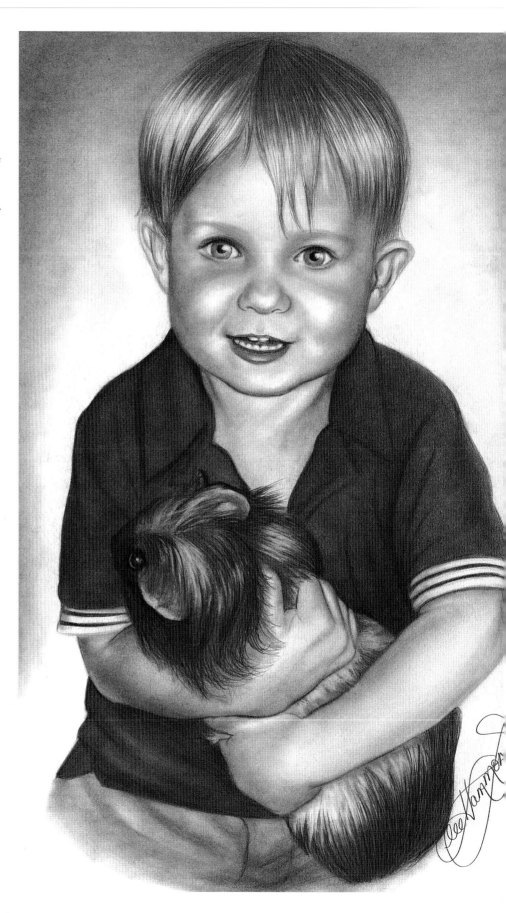

Rodent Types

Rodents come in countless shapes and sizes. Compare the differences and similarities among the following types.

Shorthaired Hamster
This is the creature most of us envision when we think of a hamster. Hamsters have features very similar to a rat. The hamster's body shape is just a little more filled out and not quite as long. Their faces are also a bit rounder. Hamsters are either solid in color or have large spots.

Zebra Mouse
A zebra mouse is like a combination of a rat and a hamster. It kind of looks like a hamster with a long tail. Its fur has interesting stripes running the length of its body.

Teddy Bear Hamster
This is a drawing of my friend's teddy bear hamster. These hamsters are very fluffy.

The Many Poses of Rodents

Drawing animals in different positions will help you fully understand their anatomies. For example, rodents such as rats are very egg shaped no matter what pose they are in. Because of their full, round body shape, their bone structure doesn't show. The skeleton of an animal is what makes it look angular. Drawing these rodents is simply a matter of elongating or shortening these egg shapes and drawing the "eggs" on their sides or upright.

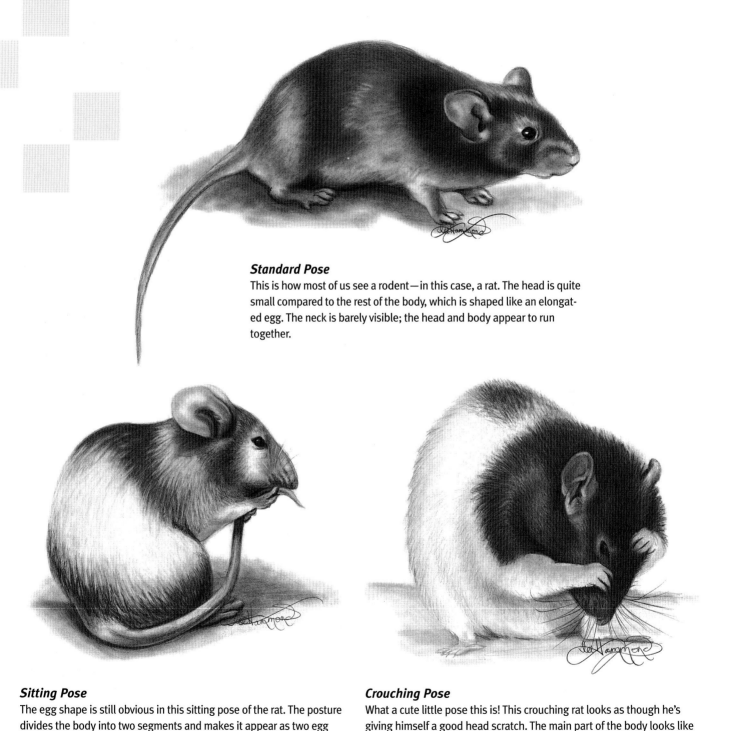

Standard Pose
This is how most of us see a rodent—in this case, a rat. The head is quite small compared to the rest of the body, which is shaped like an elongated egg. The neck is barely visible; the head and body appear to run together.

Sitting Pose
The egg shape is still obvious in this sitting pose of the rat. The posture divides the body into two segments and makes it appear as two egg shapes placed together.

Crouching Pose
What a cute little pose this is! This crouching rat looks as though he's giving himself a good head scratch. The main part of the body looks like a much squatter, fatter egg shape than in the other two poses.

Chinchilla

A chinchilla is a very small rodent with silvery fur. The pose of this one makes it look like a furry little sphere.

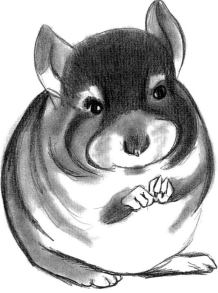

1 Make a Line Drawing

This is an easy critter to draw freehand (I drew this based on a magazine photo). The basic shape is three spheres put together (one sphere for the hind section, one for the shoulders and one for the head. Add the facial features and the triangular shapes for the ears.

2 Draw the Eyes and Add the Fur's Tones

Develop the eyes and begin adding the tones of the fur. Blend the tones with your tortillion. Try to make your drawing look like mine.

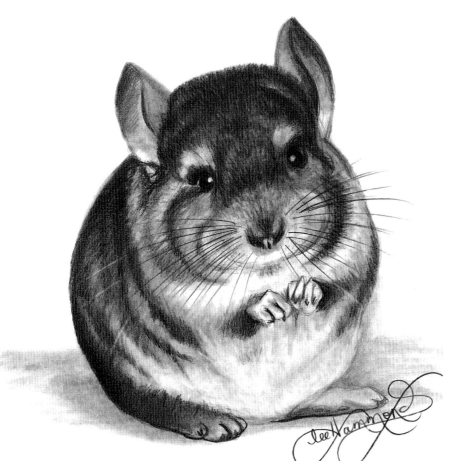

3 Build the Texture and Add Details

Reapply the tones to create the texture of the fur. Draw the details of the "hands" and feet. Add the whiskers with quick, tapered pencil strokes. The lifted light patterns on the body are crucial to making it look three-dimensional. Don't forget to lift out the tiny catchlights in the eyes to give them form.

Pictures With Props

Use artistic license and combine photographs to create your own personal statement with your artwork. It can be fun to group different props with your pet for a drawing, especially when you wouldn't ordinarily see them together.

A Lucky Snapshot
Sometimes your pet will pose with a prop and you won't have to combine photos at all. I couldn't resist drawing this when my friend brought me the photo. It is a perfect example of how to combine animals with inanimate objects for a cute effect.

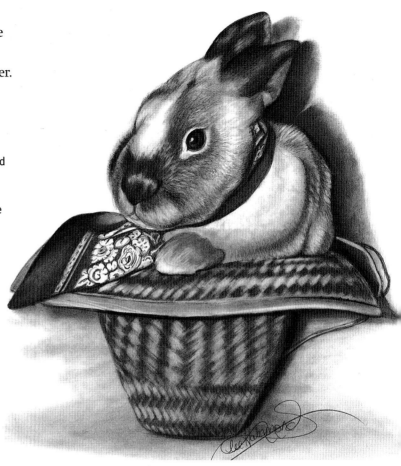

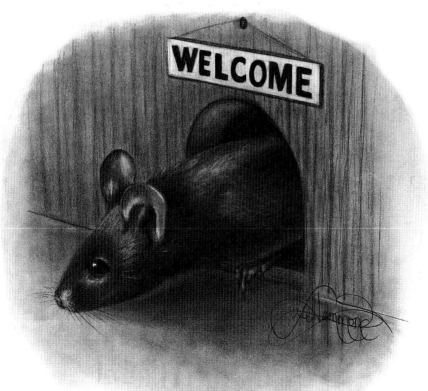

An Imaginative Scene
A little mouse coming out of a hole in the wall is the type of drawing that would be perfect for a storybook illustration.

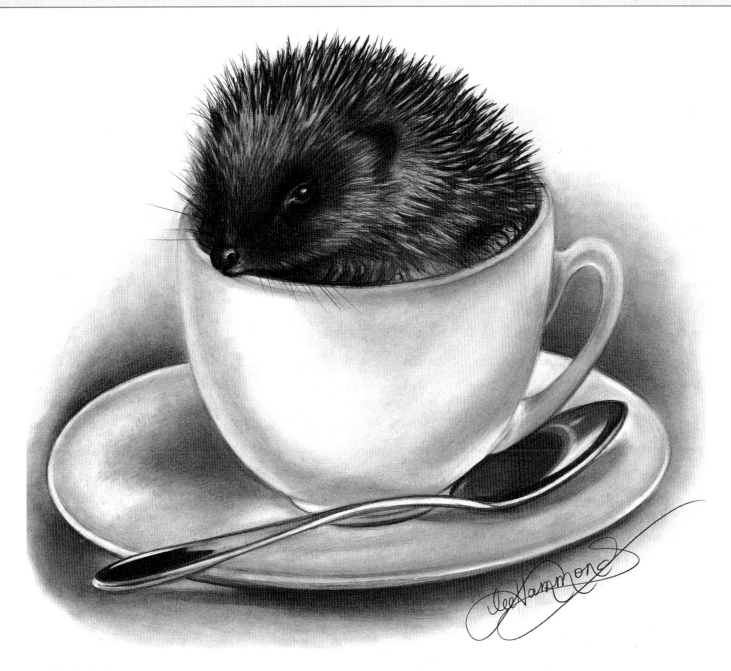

A Whimsical Picture

I could have just as easily placed this little guy in a Christmas stocking or a potted plant. Each one would have told a different story. I particularly liked drawing the hedgehog. His stiff, spiky fur was a real challenge. It required firm pencil lines and quick lifts with a kneaded eraser to create that effect.

SUBJECTS CHANGE, NOT THE PROCESS

Sometimes textures such as those seen in these drawings—wood, china, silver, straw weave—seem overwhelming to draw. If you remember that the drawing process is the same for everything, it can be less intimidating. Draw the shapes first, then the dark patterns and finally the light areas. The drawing process is the same for everything—some subjects just take more time than others to draw.

Baby Bunny

A friend of mine came to class one night with some photos of an abandoned baby rabbit her family had found. Usually a wild animal does not make a good pet, but this little rabbit was the exception. They cared for it from the time it was very young, and to this day it is very domestic and friendly.

This is a photo of her husband holding the creature in the palm of his hand. The size relationship shows how tiny the bunny really is.

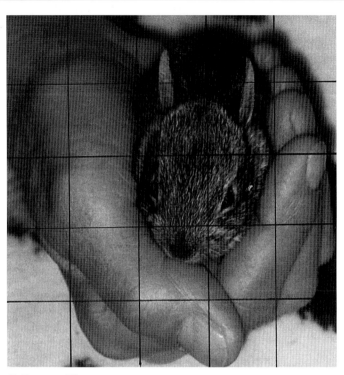

Reference Photo

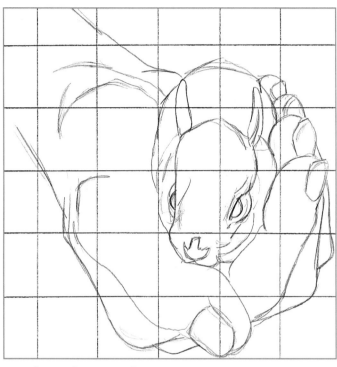

1 Make a Line Drawing

When drawing the man's fingers, look at how angular they are. Resist the urge to make them too rounded. That is a drawing mistake often made when rendering hands.

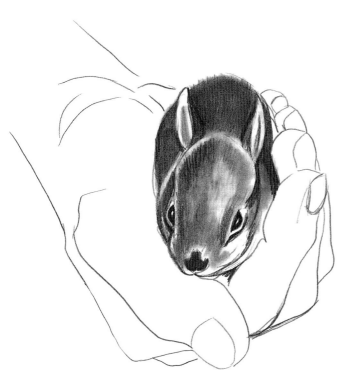

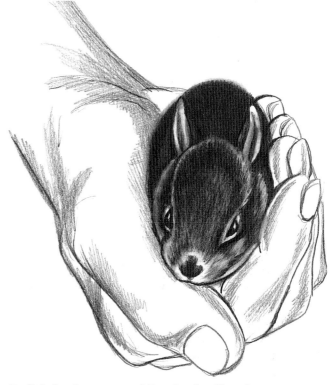

2 Draw a Furry Egg

Erase the grid lines and begin working on the bunny. Start with the eyes, and then add the tones to the rest of the body. The body is very egg shaped. Look at the top of the head. Can you see along the top the reflected light that separates the head from the back?

Blend the tones with a tortillion and then continue to create the fur's texture with your pencil.

3 Build the Layers and Begin the Hand

Continue building the fur with layers of pencil. Lift out light hairs, reflected light and other light areas with a kneaded eraser.

Begin rendering the hand. The five elements of shading are evident here as well. Look at the reflected light along the edges of the fingers. Add to each finger the dark tones that represent the shadow edges.

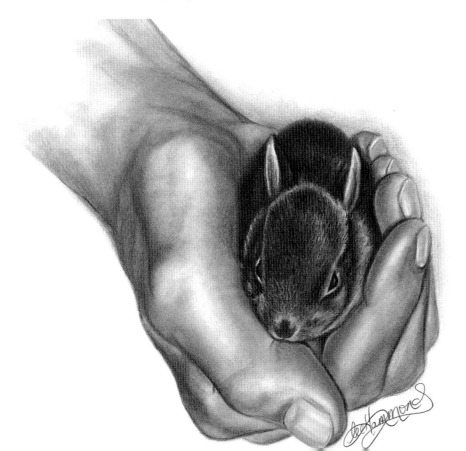

4 Finish the Hand

Soften the lighter areas of the bunny. Keep adding tones to the hand and blending them until they appear smooth and realistic. This will take some time, so be patient and keep working until your drawn hand resembles this one.

8 Birds

Many people prefer feathered friends to furry pets. I love drawing birds and have written an entire book on how to draw the various species (DRAWING IN COLOR: BIRDS; North Light Books). This chapter will show you how to convincingly draw feathers and how to make beautiful drawings using birds as your subject matter.

Lovebirds

This drawing was fun because of its story-telling capability. Lovebirds are always found in pairs. The heart shape in the background reinforces the bond seen between them. This view shows the fluffiness of the birds when seen from the front. Their colors are not distinct but gently blend together to create gradual tones. The feathers of a bird are not as distinct in the front—they are more like fluff.

LOVE TO DRAW LOVE BIRDS
12" × 9" (30CM × 23CM)

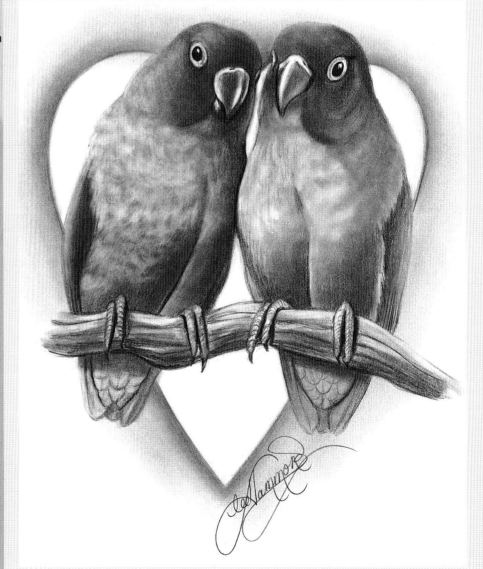

Drawing Feathers

Drawing feathers is much like drawing the shingles of a roof or the petals of a flower. It is a matter of rendering overlapping surfaces, one feather or group of feathers over another. Each layer of feathers has a cast shadow below it and reflected light along its edges. If you can remember this as you draw, it will all come together. If you take it slow, it isn't as difficult as it looks.

A feather is divided down the middle with a quill, or spine. Look for this definition when you are drawing feathers. Depending on your point of view as you draw, the spine will not always appear to be directly in the center of a feather. This will vary from feather to feather within the same drawing.

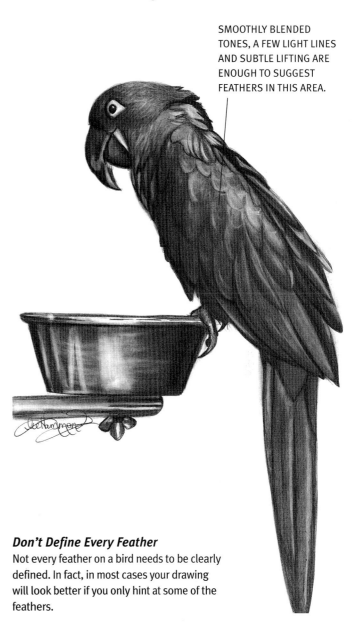

FEATHERS OVERLAP LIKE THE SHINGLES ON A ROOF.

REFLECTED LIGHT

CAST SHADOW

LOOK FOR WHERE THE FEATHER IS DIVIDED DOWN THE MIDDLE. HERE WE SEE MORE OF THE RIGHT SIDE OF THE FEATHER, SO IT APPEARS CLOSER TO US.

SMOOTHLY BLENDED TONES, A FEW LIGHT LINES AND SUBTLE LIFTING ARE ENOUGH TO SUGGEST FEATHERS IN THIS AREA.

Don't Define Every Feather
Not every feather on a bird needs to be clearly defined. In fact, in most cases your drawing will look better if you only hint at some of the feathers.

Cockatiel

This is a popular pet among bird lovers. This cockatiel belongs to a friend of mine. I really like this pose and the way his head is turned to look at us. The cockatiel is less complicated to draw than other birds, which makes it a good one to start with for a drawing exercise.

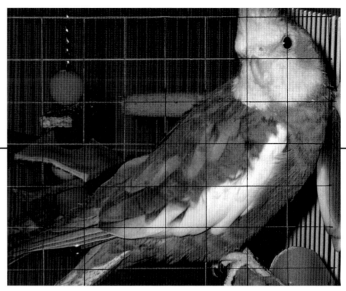

Reference Photo

1 Make a Line Drawing

Be sure to capture the shapes and correct placement of the feathers. The grid makes this much easier to do.

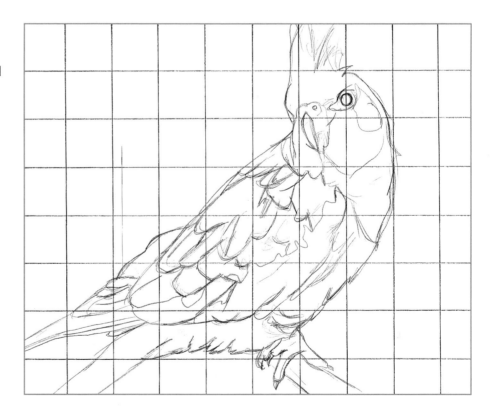

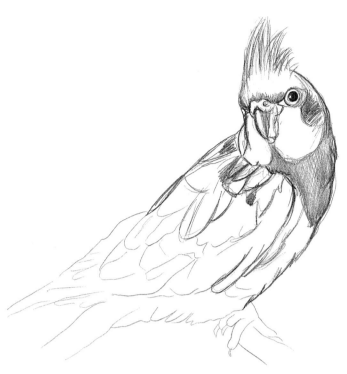

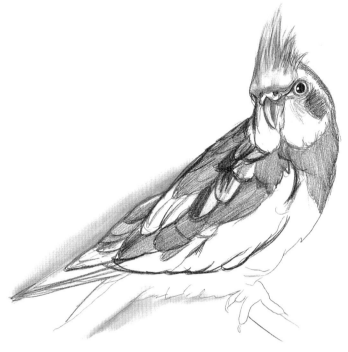

2 Develop the Head

Remove the grid lines and start rendering the head and face. Carefully render the eye and the beak area, checking your shapes for accuracy. Create the hairs on top of the head with quick, tapered strokes.

3 Move Down the Body

Create the tones of the body and its feathers. Be sure to overlap the feathers, seeing them as you would the shingles of a roof. Render the shadows underneath each feather.

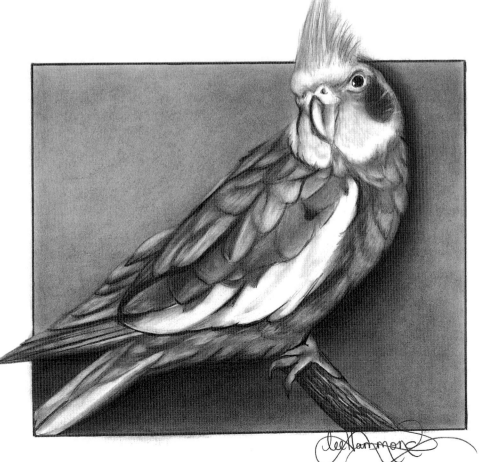

4 Blend Tones, Lift Out Highlights and Add the Background

Blend the tones to make the feathers look smooth. With a kneaded eraser, lift out highlights in the feathers and the reflected light along their edges. Add shading to the background to make the bird stand out more. Add a border box for visual impact, allowing the bird to escape the borders for interest.

Macaw

This was a pet macaw kept in a restaurant in Puerto Vallarta, Mexico. He was quite the talker and a big hit with all of the patrons. I loved his personality and beautiful colors, which are mainly a deep red.

Because the details of a parrot's head are so intricate, we'll render it first before moving onto the body. I have included a mini-demonstration of the head by itself on the following page so you can see the details more easily. Render it completely before you work your way down to the feathers of the body.

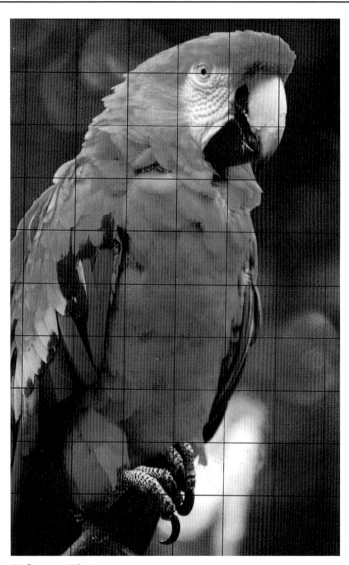

Reference Photo

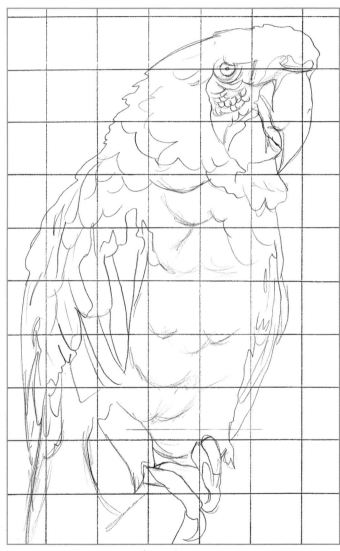

1 Make a Line Drawing

Try to capture the outline of as many feathers as you can. This is important because there is a definite pattern in which the feathers grow.

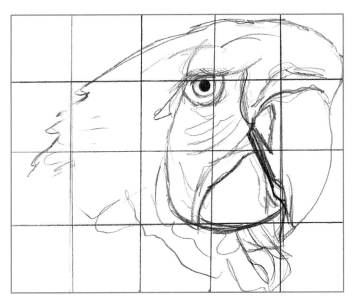

2A Double-Check the Head's Shapes

Check your line drawing for accuracy before erasing the grid. The shapes must be right before you begin shading. Then, make the pupil of the eye extremely black.

2B Add Tones

The head is darkest where it meets the beak area. Add black to the beak as well. Make the head look feathered and textured, following the direction of feather growth.

2C Blend and Refine the Details

Re-create the scalloped patterns of the skin around the eye. Blend the feathers and build them up with additional pencil strokes. Don't forget to include the shadows underneath each feather. Blend the tones of the beak to help create its smooth roundness. Lift out areas of reflected light on the feathers and beak with a kneaded eraser.

3 Create the Body's Feathers

Work your way down the body of the bird, rendering individual feathers. Create the shadows and lift out the reflected light on each one. Build your depth of tone by adding pencil and blending between applications. Work down to the claws and the branch. Notice that the area under the breast isn't as defined— as shown in the reference photo—which lends a more realistic look.

To best show the light reflecting off of the feathers, I chose to fill in the background. This also gives the drawing a dramatic look. The background tone enhances the look of the feathers.

4 Add Final Touches and Finish the Background

Finish the feet and the branch, using very deliberate pencil strokes to render both of these highly textured areas. Lift out the highlights from these surfaces with your kneaded eraser. Finish adding tone to the background, and be sure to blend it well to make it look smooth and even.

More Birds

Let's look at a couple of smaller pet birds and at one large bird that is typically no one's pet but can be spotted rather quickly in many areas.

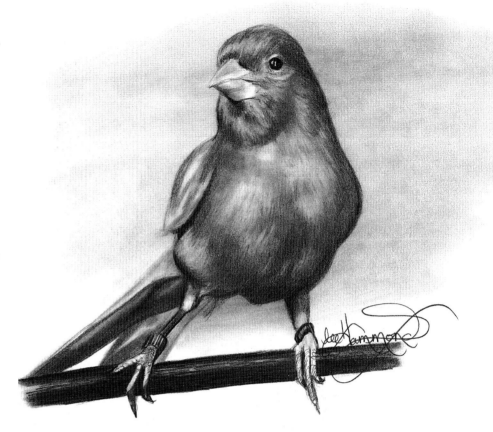

Canaries

This little canary reminds me of my childhood. Canaries used to be much more popular as pets, and my grandmother had one named Dickey. I remember feeding him little pieces of lettuce. This drawing looks just like him. Artwork is a great way to capture and preserve meaningful memories and moments.

Canadian Geese

Not all pets are kept in cages, and birds are no exception. A friend of mine who lives on a farm adopted this goose. It has become dependent on humans, and it will eat right out of her hand.

It is fun to draw waterfowl partially because of the opportunity to re-create water reflections. You can see how the reflection is actually a mirror image. The circular ripples show the movement of the water. The water was created with light and dark patterns that were blended smooth. The light ripples were lifted out with a kneaded eraser.

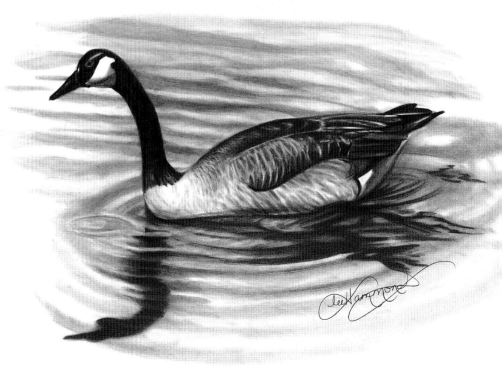

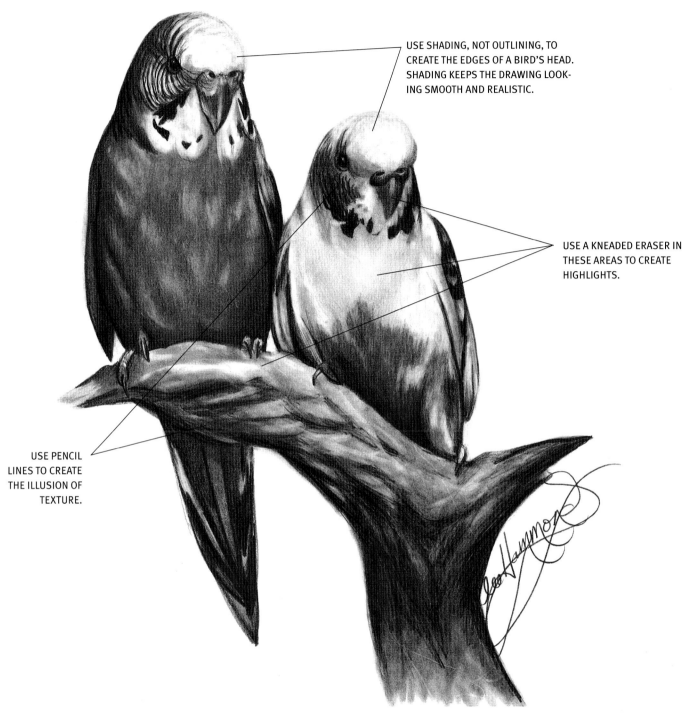

USE SHADING, NOT OUTLINING, TO CREATE THE EDGES OF A BIRD'S HEAD. SHADING KEEPS THE DRAWING LOOKING SMOOTH AND REALISTIC.

USE A KNEADED ERASER IN THESE AREAS TO CREATE HIGHLIGHTS.

USE PENCIL LINES TO CREATE THE ILLUSION OF TEXTURE.

Parakeets

Parakeets are favorites for many young bird lovers. These birds are frisky but highly trainable. Without a background, this drawing allows the attractive feather patterns of these birds to take center stage.

I drew this from a magazine about pet birds. Check out your local pet store for the huge variety of magazines they offer for pet owners. Those magazines are loaded with good photo references for drawing practice.

9 Reptiles & Fish

Some pet owners prefer the scaly types. My oldest daughter always seemed to prefer snakes and lizards when she was growing up. I had my fair share growing up as well. I remember my chameleon getting out of his cage once. I had no idea where it went until my poor mom opened my closet to put some clothes away, and there it was, staring at her from the wall. Needless to say, my days of owning a lizard were encouraged to be short! Today, I have to admit I still love reptiles, but only in my artwork.

The varieties of reptiles and fish are endless, so we will cover a few of the more popular types in this chapter.

The Unique Textures of the Iguana
I chose to crop the photographic image and concentrate on the face. I really enjoyed drawing the various textures of this iguana. The countless pencil lines and circles were crucial to accurately convey the different areas of its skin.

PORTRAIT OF AN IGUANA
12" × 9" (30CM × 23CM)

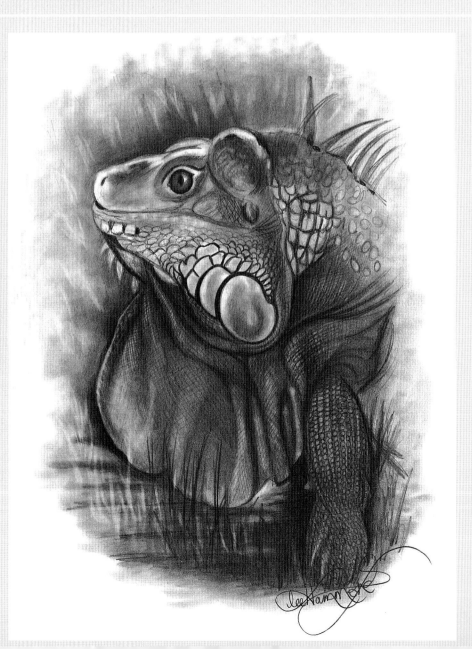

Types of Lizards

There are a variety of lizards that people enjoy as pets. Here are just a few of them. All of them make good subjects for drawing, and each one lends unique challenges to an artist.

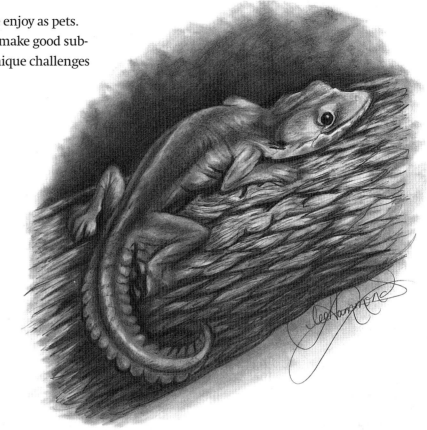

Gecko

This gecko's coloration and tones were so similar to the bark of the tree that it was hard to see where one ended and the other began. That is what nature designed for him for protection, so that's the way I drew him. I was careful here to capture the anatomy, especially in the head structure and the spine. What makes this lizard most unique is the scalloped edge of the tail—it looks like lace.

The tree bark texture was created using very dark, firm pencil lines, which make the recessed areas of the bark stand out. The light areas were lifted out with a kneaded eraser, and then small lines were pencilled in for more texture.

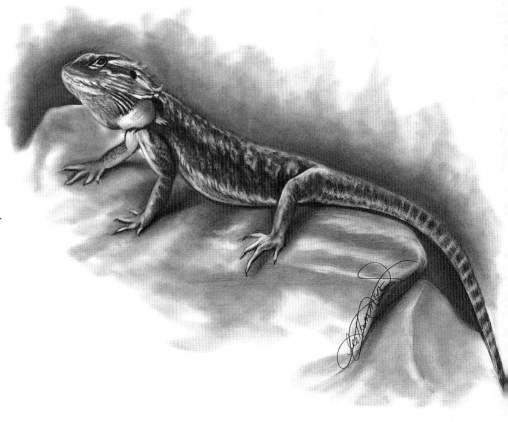

Bearded Dragon

To me, this creature's body structure looks similar to that of an iguana, but the wispy protrusions on its face make it look much different. When drawing creatures like this, look at the patterns and textures of the skin. The tail, for instance, has a very distinct repeated design.

Look at the way I used shading and shadows to give the drawing a finished, realistic look. The shadow below the lizard makes the drawing look three-dimensional. The background tone behind the lizard makes the light across its back show up more.

Iguana

This iguana was a pet that lived in a resort area in Cozumel, Mexico, that I visited on one of my art cruises. What I loved most about him was his size, which seemed to be about four feet (1.2m) long, and his bright orange color, which is totally different from the green iguanas I am accustomed to. He wasn't afraid of people, and he allowed me to have quite a photo shoot until he tired of me and scurried into the bushes.

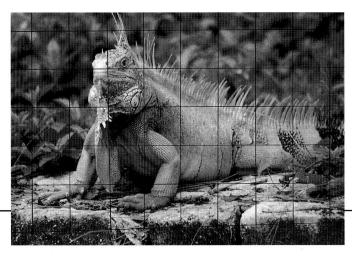

Reference Photo

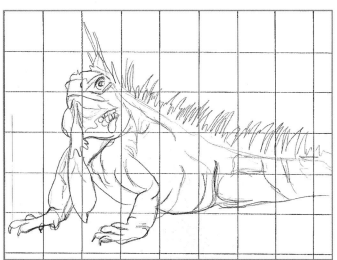

1 Make a Line Drawing
Even in this simplistic form, this iguana has a regal look to him.

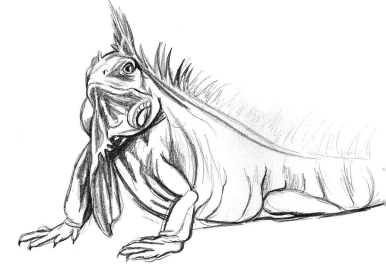

2 Render Darkest Areas First
Erase the grid lines and start rendering the darkest areas of the face, beginning with the eye. Work your way down the upper body. Look for small details as you work. At this stage, the head begins to have dimension.

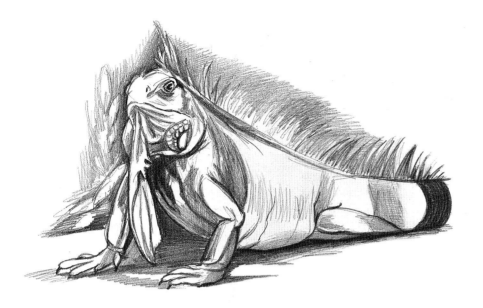

3 Add Tones to the Body and Surrounding Areas

Continue adding tones to the body. Start adding some of the background to define the light spines running down the creature's back. Place some of the stripelike markings on his lower half. Add shadows beneath the iguana to make him stand out against the foreground.

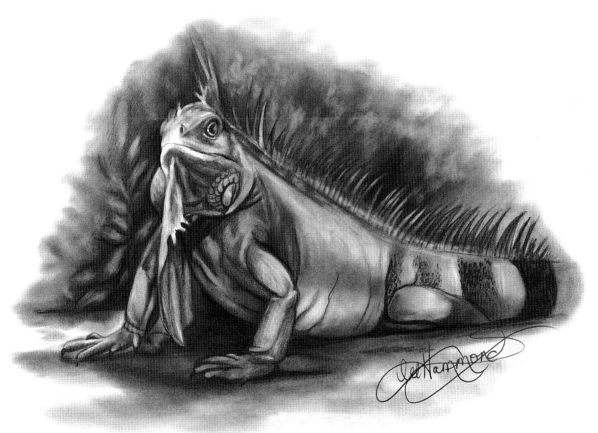

4 Blend, Lift and Deepen Tones

Blend the tones and intensify the dark areas with your pencil for more contrast. Lift out the lighter highlight areas with a kneaded eraser. Deepen the background tones, but make sure they look out of focus (blend them well) for a better illusion of depth.

Other Cold-Blooded Creatures

Here are a few other not-so-cuddly creatures that people commonly keep as pets.

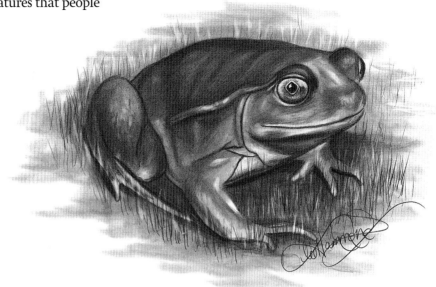

Frogs

A frog is actually an amphibian, capable of living both in water and on land. I blended out the pencil strokes to create this frog's smooth skin. To make the skin look shiny, I used the kneaded eraser to lift highlights.

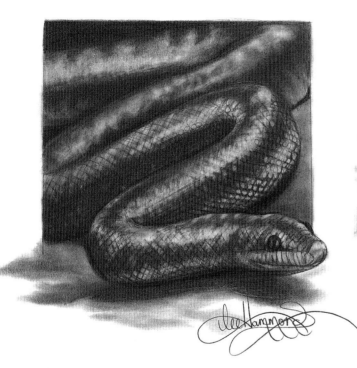

Turtles

I am the proud owner of an African water turtle like this one. It has a less domed shell than a common box turtle. The markings on the shell, face and neck make turtles interesting subjects to draw. Contrast is essential to rendering a realistic turtle, so look for the areas of light and dark and how they create patterns.

Snakes

Re-creating a snake's shape is great practice for drawing cylindrical forms and rendering the five elements of shading. For this drawing of a rosy boa, I used the border-box effect to make the snake look like it is projecting forward.

Although snakes look very scaly, they actually are quite sleek. The scales fit together like the pieces of a puzzle, and the shadows are created by the overall shape of the snake, not by individual scales. I created the illusion of depth by diminishing the snake's details as its body trailed further away—it seems to fade into the background.

Aquarium Fish

I absolutely *love* aquarium fish, and everyone who knows me knows that. I have a tank in nearly every room of my house, and each one houses a collection of beautifully colored goldfish and koi.

These drawings show just a few of the many fish that people keep as pets. Each kind is a bit different, but all of them are fun to draw.

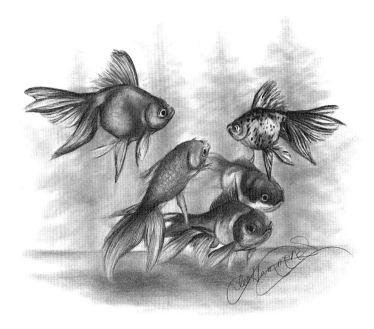

Goldfish

I think goldfish have personalities, much more so than tropical fish. Goldfish come in many different species and characteristics. Some are calico, others are pitch black and some are pure orange. Their tails also vary from short to long, from flowing to fan shaped. Whatever type they are, all are drawn the same: Render the shape first, then work on patterns of light and dark.

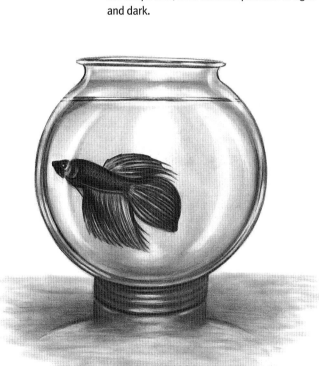

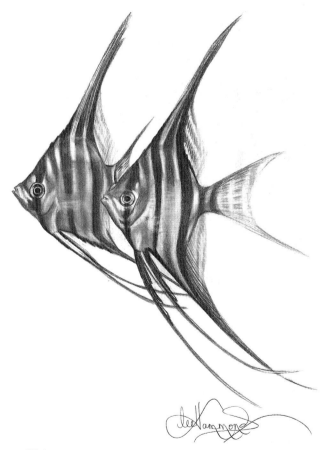

Bettas

Bettas are also known as Siamese fighting fish and therefore must be kept separated from others of their breed. However, I place one in each of my goldfish tanks, and they do fine. They come in a variety of colors, from very light to very dark.

Bettas are easier than other fish to draw from life because they tend to remain in one spot for longer periods of time. This gives you more time to capture them.

Angelfish

Angelfish have delicate lines and patterns. I've always been mesmerized by their beautiful shape and long, cascading fins. I drew these from a magazine I found at a pet store.

Turtle

Turtles have been a part of my life as long as I can remember. I always had one as a child, and my kids were constantly finding them and bringing them home. Our rule on finding turtles was you could keep them for a while, but then they had to be returned to nature to hibernate.

This is a painted turtle that lives at our local petting zoo. We visit the turtles there every year. If we find a turtle crossing a road, this is where we take it for safety.

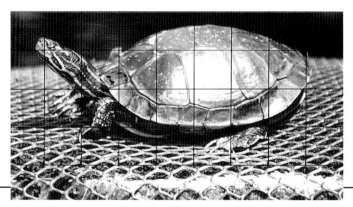

Reference Photo

1 Make a Line Drawing
Capture the basic shapes of the turtle.

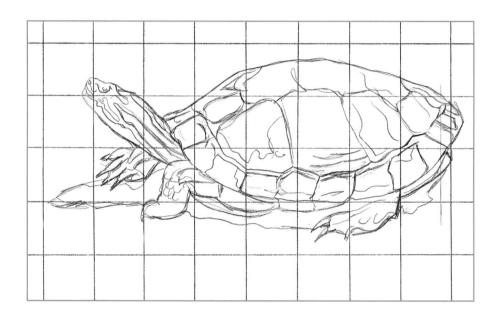

2 Start the Head, Neck and Legs
Remove your grid lines and begin rendering the head, neck and legs. Look for the patterns, and let your dark areas create the light ones.

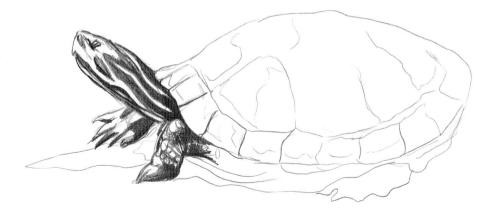

116

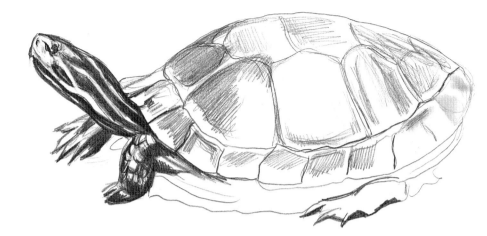

3 Begin the Shell

Start adding tone to the turtle's shell. It is made up of patterns, too. Work one area at a time.

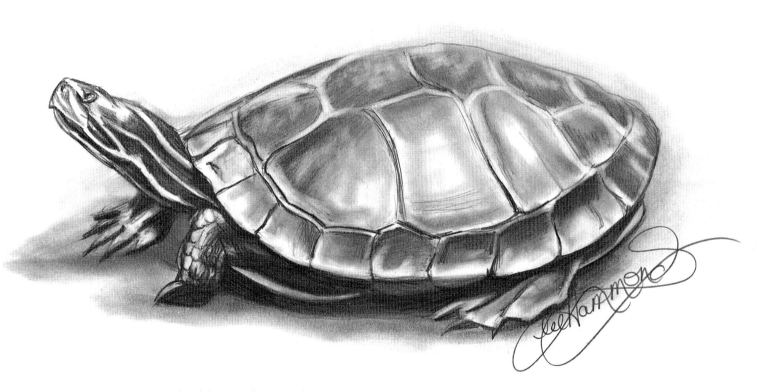

4 Blend the Tones and Add a Background

Blend the tones to replicate the smoothness of the turtle's shell, and lift out the highlights with a kneaded eraser. Apply some dark tones to the background and below the turtle for the shadows. This makes the light areas of the turtle stand out.

Cichlid

Cichlids are large, aggressive fish with interesting patterns and colors on their bodies. This is a demonstration featuring my friend's Jack Dempsey cichlid, Wallace.

TRUST YOUR EYE WHEN DRAWING PATTERNS

When drawing a fish that has a lot of spots and patterns, try to be as true as possible to what you actually see. Rarely is a pattern perfect, but your brain will try to make you draw it that way. You don't want to end up with a polka-dotted fish! Capture the pattern with all its imperfections or irregularities.

Also bear in mind the angle at which you are looking at the fish. As the fish recedes into the background, so should its patterns.

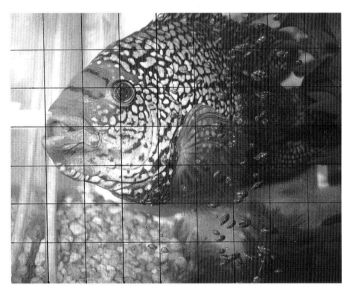

Reference Photo

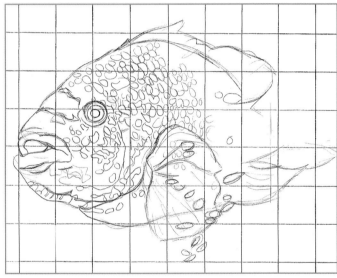

1 Make a Line Drawing

This fish has a ton of spots, so try to be as accurate as possible in capturing the patterns. It is okay to be off a little bit, but the patterns are important.

2 Carefully Work on the Pattern

With this much patterning, it is important to not erase it all when removing your grid lines. Begin with rendering the eye, and then start to fill in the dark areas between the light spots to create the fish's patterns. As you are filling in the spots, use your kneaded or typewriter eraser if you fill in too much and need to open up the spots. Rough in some circular shapes for bubbles.

3 Continue the Pattern

Continue filling in the dark areas to finish the patterns. As the fish recedes into the background, the patterns become smaller and smaller. Blend the area on the top of the head to make it look very smooth. Start to create the look of an aquarium in the background by roughing in some plant life.

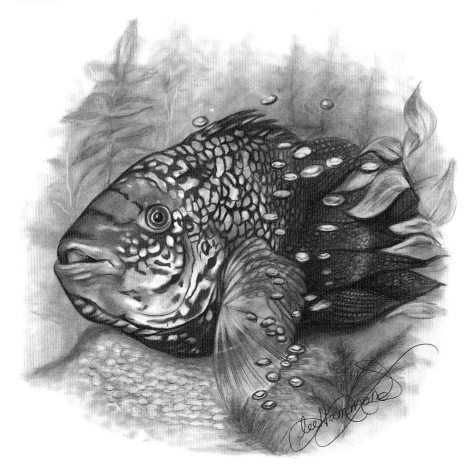

4 Finish the Scenery

The background, especially the illusion of water, is very important in this drawing. Develop the plant life behind the fish and the look of gravel below it. Make these areas appear out of focus—as they would underwater—by blending heavily with a tortillion. Develop the bubbles as little spheres. The drawing seems to fade into the distance, giving it depth.

10 Storytelling Through Pictures

Now that you have the drawing skills necessary for good illustration, it is time to let your artwork communicate something to the viewer, who may have never met your pet. A portrait can tell you what something looks like, and perhaps a little about the subject's personality, but true "illustration" does more. It actually tells the viewer a story, whether by including the animal's surroundings, showing its interaction with others or capturing a telltale moment that reveals your pet's personality.

A Cozy Moment

This is a drawing of my friend's daughter with their new Yorkie puppy. You can actually feel the love she has for her new pet when you look at this drawing. Artistically, I loved the expression of the little girl and the way her eyeglasses rested on her tiny nose. The puppy looks very content in her arms. There is no sign of struggle, just pure coziness!

MORGAN AND HER NEW PUPPY
14" × 11" (36cm × 28cm)

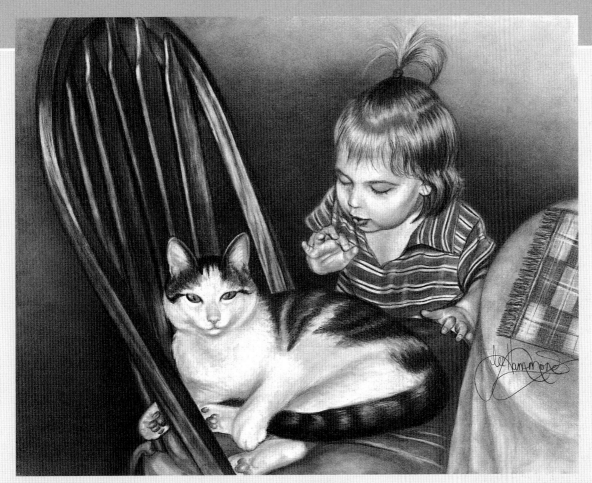

A Touchy Situation

This is a drawing of my granddaughter Caitlynn with my cat Meowser, a Domestic Shorthair. It shows the hesitancy of a toddler to actually touch an animal. She absolutely loves kitties, but she is very shy. She wasn't sure if she should reach out or not.

By including the entire scene, I can actually place myself in my kitchen when I look at this piece. A photograph can accomplish the same thing, but I think artwork like this is much more emotionally provoking.

CAITLYNN AND MEOWSER
11" × 14" (28CM × 36CM)

An Intimate Moment

Sometimes a small, simple drawing can speak volumes. This drawing doesn't set an elaborate scene, but it captures a real mood and tells a story. This is what illustration is all about.

STOP AND SMELL THE FLOWERS
9" × 12" (23CM × 30CM)

SKETCH VS. ILLUSTRATION

Illustration is different from sketching. Sketching is a method for quickly capturing the subject matter and its shape on your paper. It is loosely done, and the small details are often not included.

Illustration, on the other hand, is a tightly rendered depiction of your subject that is realistically drawn. It is more than just the drawing, though; it is a method of storytelling. It includes the details of the entire scene that tell you what your subject is doing and often what it is feeling.

A Familiar Activity

Drawings should be a representation of your pets' personalities and how they live their lives. Tippy, my black Labrador mix, passed away a few years ago. She was a very docile animal, and this drawing will always make me remember how she loved to spend time just lying in the shade in the yard.

A RELAXING AFTERNOON WITH TIPPY
11" × 14" (28CM × 36CM)

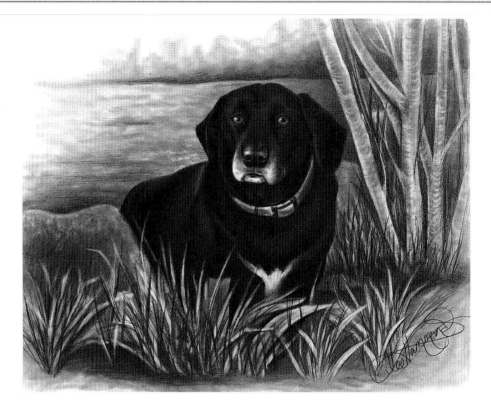

A Handy Creature

This leopard gecko belongs to one of my friends. It is very friendly and seems to enjoy being held. I like this drawing because the hand establishes a size perspective and also gives the impression that this is indeed a pet.

DRAWING OF GEX
10" × 8" (25CM × 20CM)

122

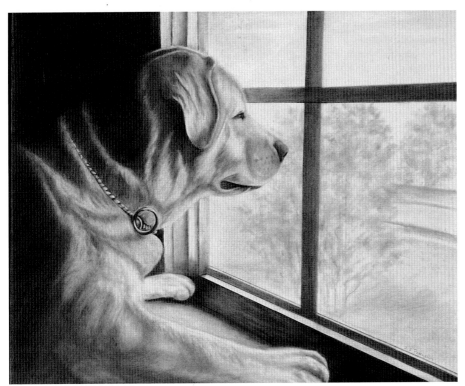

An Everyday Scene

This drawing, done by one of my students, depicts the personality of a family pet and tells a very emotional story. It shows the devotion an animal has to its owner. You can feel the love this dog, a yellow Labrador, has for its owner, as it patiently waits in the window for her to come home. The window light illuminates and places focus on the dog's face. These types of details are very important when storytelling with your artwork.

WAITING
ARTIST: JACKIE PETERSON
14" × 17" (36CM × 43CM)

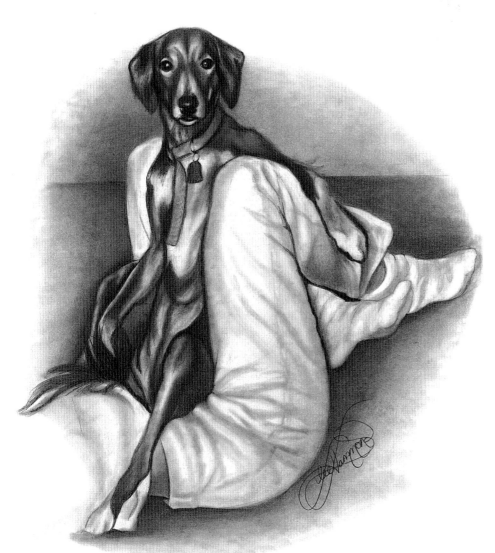

An Unusual Pose

Unusual poses make cute artwork. This is my dog Penny, a greyhound/sheltie mix, when I first brought her home. She always has been a strange little dog personality-wise. My daughter was lying on the floor watching TV, and Penny kept trying to climb into her lap. Somehow she managed to find herself in this pose, and luckily I had my camera ready. She looks almost humanlike in her positioning. The funny thing is Penny acted as if this was perfectly normal!

WATCHING TV WITH PENNY
14" × 11" (36CM × 28CM)

123

Conclusion

The drawing on this page is special to me and my kids. It shows one of the many turtles we have rescued over the years. This drawing captures the time when we took it to the petting zoo to release it into a new home. It crawled away into the bushes and then turned around as if to say, "Good-bye." Telling a story and evoking a memory is what artwork should do for the viewer. That is what good illustration is all about.

Now it is up to you to take it from here. Hopefully this book has inspired you to take your artwork to a new level and to try some things that you haven't tried before. I encourage you as an artist to do what I do and to experiment with all types of subject matter. I hope this book has made you creatively curious and you will try to draw not only the familiar but also subjects you have not considered before.

Draw as much as possible to fine-tune your skills. Take the basic information from this book and allow your own personal drawing style to develop. Everyone sees things differently, and each artist has a bit of a different approach. Have fun with your work, and good luck to you as you discover your own unique style of drawing.

SAYING GOOD-BYE
11" × 14" (28CM × 36CM)

Telling Body Language

It is not always necessary to include the face of something to show feeling. This drawing of Penny is an example of that. From behind, you can almost feel what she is thinking as she guards the backyard. You can sense her looking into the distance, ready to address anything that comes into her private domain.

GUARDING THE YARD
14" × 11" (36CM × 28CM)

Pets are a huge part of our lives. They can enhance our everyday existence in more ways than I can describe.

Our animal shelters are overflowing with awesome animals looking for homes. Maybe you can help. If everyone who reads this book opened their home to just *one* more pet, what a wonderful job we would do in preventing the unnecessary deaths of thousands of innocent creatures. I'm off to the shelter!

Index

Learn to draw with these other fine North Light Books!

Lifelike Drawing with Lee Hammond
By Lee Hammond, ISBN- 13: 978-1-58180-587-1, ISBN- 10: 1-58180-587-X, paperback, 160 pages, #33058

You can draw anything—flowers, people, animals, even water and glass—with this expansive, in-depth "Drawing Bible," by veteran artist and instructor Lee Hammond. Learn to draw realistically the easy way using reference photos with Lee's simple techniques and clear step-by-step instruction. Whether you're just beginning or more experienced, Lee's instruction will give you everything you need to know to create realistic drawings that will "wow" your audience.

Drawing in Color: Animals
By Lee Hammond, ISBN-13: 978-1-58180-273-3, ISBN-10: 1-58180-273-0, paperback, 80 pages, #32144

Lee Hammond's amazing, easy-to-follow techniques enable even first-time artists to render a variety of wonderful animals, from cats and dogs to horses, squirrels, tigers and more. Hammond's special graphing system makes all the difference, enabling the reader's brain to translate animal poses from a picture into startlingly realistic drawings on the page. Additional guidelines detail the methods used to duplicate eyes, ears, mouths, feet, fur and hides. Readers will also learn how to layer, blend and shade their work, just like the pros!

Draw Now: 30 Easy Exercises for Beginners
By Ruth Glenn Little, ISBN-13: 978-1-58180-595-6, ISBN-10: 1-58180-595-0, paperback, 96 pages, #33108

Ruth Glenn Little has drawn upon her 20 years of experience teaching drawing skills and the building blocks of artistic success to create this easy-to-understand guide for beginners. Turn to this book for easy exercises that teach progressive skills with reader-friendly instructions, a complete glossary of terms and "no accessories required" lessons that allow readers to just pick up a pencil and begin learning.

Strokes of Genius
By Rachel Rubin Wolf, ISBN-13: 978-1-58180-861-2, ISBN-10: 1-58180-861-5, hardcover, 144 pages, #Z0271

Here is your chance to learn from more than 100 talented artists. Strokes of Genius features page after page of gorgeous drawings along with insightful comments from their creators, giving you not only a rare, insider view but also the approach and style of multiple artists.

These books and other fine North Light titles are available at your local arts & craft retailer, bookstore or online supplier.